Hidden Heritage:

Afro-American Art, 1800-1950

Hidden Heritage:
Afro-American Art, 1800-1950

David C. Driskell

Organized by
Bellevue Art Museum
Bellevue, Washington
and
The Art Museum Association of America

EXHIBITION TOUR

Bellevue Art Museum
Bellevue, Washington
September 14–November 10, 1985

The Bronx Museum of the Arts
Bronx, New York
January 14–March 10, 1986

California Afro-American Museum
Los Angeles, California
April 7–June 2, 1986

Wadsworth Atheneum
Hartford, Connecticut
July 4–August 31, 1986

The Mint Museum of Art
Charlotte, North Carolina
September 22–November 17, 1986

San Antonio Museum of Art
San Antonio, Texas
December 15, 1986–February 9, 1987

The Toledo Museum of Art
Toledo, Ohio
March 8–May 3, 1987

The Baltimore Museum of Art
Baltimore, Maryland
June 1–July 27, 1987

The Pennsylvania Academy of the Fine Arts
Philadelphia, Pennsylvania
August 23–October 18, 1987

Oklahoma Museum of Art
Oklahoma City, Oklahoma
November 15, 1987–January 10, 1988

Copyright 1985 by The Art Museum Association of America, 270 Sutter Street, San Francisco, California 94108.

All rights reserved.

Edited by James Liljenwall
Graphic design and production:
 Ed Marquand Communication Design
Typesetting: The Type Gallery
Printing: Nissha Printing Co., Ltd., Japan

Library of Congress Catalogue Card Number 85-071873

ISBN 0-930295-03-X

Printed in Japan

Front Cover Illustration:
Horace Pippin
JOHN BROWN GOING TO HIS HANGING. 1942
Oil on canvas
24 x 30 in.
Collection of The Pennsylvania Academy of the Fine Arts

Back Cover Illustration:
Henry O. Tanner
THE THANKFUL POOR. 1894
Oil on canvas
35½ x 44¼ in.
Collection of Dr. and Mrs. William H. Cosby, Jr.

Philip Morris believes in drawing attention to important parts of our American culture that have been previously overlooked. The nearly one-hundred exhibitions we've supported in the United States have highlighted southern painting and folk art, art reflecting the American West, art by Blacks, art by women, and art from California, Georgia, and Wisconsin.

Hidden Heritage is just such an exhibition. By rights, all the artists in this show should have been recognized long ago. That they haven't been reveals the loss we all suffer from our past omissions. Their works demonstrate that for over a century Black artists have distinguished themselves in virtually every American style and mode of expression.

That kind of diversity is something else we believe in. Freedom of expression is as important in the arts as it is in politics and the choices that individuals make about the ways they live.

Philip Morris is pleased to help celebrate our important hidden heritage. We hope you enjoy the exhibition and this catalogue.

Hamish Maxwell
Chairman and Chief Executive Officer
Philip Morris Companies Inc.

LENDERS

Allen Memorial Art Museum
Amistad Research Center
Francine and Marilyn Aron
The Atlanta University Collection of Afro-American Art
Atwater Kent Museum, The History Museum of
 Philadelphia
The Baltimore Museum of Art
Barbara Johnson Collection
Brandywine River Museum
California Afro-American Museum
Elizabeth Catlett
Corcoran Gallery of Art
Dr. and Mrs. William H. Cosby, Jr.
Dallas Museum of Art
Marc-Primus Davy
Des Moines Art Center
Professor and Mrs. David C. Driskell
The Evans-Tibbs Collection
Fisk University Museum
Gallery of Art, Howard University
Hampton University Museum
Heritage Gallery, Los Angeles
Mr. and Mrs. John H. Hewitt
Lois M. Jones
Mr. and Mrs. David E. Leven
Professor and Mrs. James E. Lewis
Luise Ross Gallery, New York
Maryland Commission of Afro-American History and
 Culture
Mr. and Mrs. Daniel Mechnig
Meta Warrick Fuller Legacy, Inc.
The Metropolitan Museum of Art
Ozier Muhammad and Carol Penn-Muhammad
The Museum of African American Art
Museum of Art, Rhode Island School of Design
National Museum of American Art
The Newark Museum
North Carolina Museum of Art
Onyx Gallery, New York
The Pennsylvania Academy of the Fine Arts
The Phillips Collection
Stephanie E. Pogue
Private Collections
Provincial Archives of British Columbia
Mr. and Mrs. Richard Rosenwald
San Francisco Museum of Modern Art
San Jose Public Library
Selma Burke Gallery, Winston-Salem State University
The Shomburg Center for Research in Black Culture,
 New York Public Library
Dr. Meredith Sirmans
Mr. and Mrs. Haig Tashjian
Terry Dintenfass Gallery, New York
The Toledo Museum of Art
Tuskegee Institute
George and Joyce Wein
Western Illinois University Art Gallery/Museum

ACKNOWLEDGMENTS

Work by Black painters and sculptors has been omitted too frequently from major exhibitions and scholarly surveys of American art. As a result, the public has rarely been able to see work by such important American artists as Joshua Johnston, Robert Duncanson, Edward Bannister, Edmonia Lewis, Henry O. Tanner, Horace Pippin, Palmer Hayden, Aaron Douglas, Romare Bearden, and Jacob Lawrence. Still less have viewers been able to develop a sense of the context within which each artist worked. It is our hope that *Hidden Heritage: Afro-American Art, 1800-1950* will help rectify this situation by presenting the work of each of these artists in some depth and by showing several works each by a number of their lesser-known contemporaries, thus suggesting the breadth and range of Black artistic production in America.

 This exhibition has evolved as a close collaboration between the Bellevue Art Museum and The Art Museum Association of America. Many individuals and institutions should be acknowledged for their generous contributions.

 I would first like to thank Philip Morris Companies Inc. for underwriting the cost of producing this catalogue and for helping to sponsor the exhibition tour.

 On behalf of the ten museums participating in the tour, I want to thank the lenders to the exhibition who have so generously agreed to share their prized possessions for the two-year loan period.

 I especially want to thank David Driskell for his insightful catalogue essay and both Dr. Driskell and John Olbrantz for their thoughtful selection of works.

 In San Franscisco Miriam Roberts, Exhibition Coordinator at the Association, deftly and enthusiastically orchestrated all aspects of this at-times unwieldy project; Beth Goldberg, Registrar, has arranged and monitors the two-year tour; and Bradin Anders, Exhibition Assistant, has aided both of them in the myriad exhibition details. James Liljenwall also deserves special thanks for skillfully and sensitively editing the final manuscript of the catalogue.

 All of us at The Art Museum Association of America are very proud to have helped produce *Hidden Heritage: Afro-American Art, 1800-1950*, and we hope this important exhibition will increase public and scholarly awareness of the rich diversity of our full artistic heritage.

Harold B. Nelson
Exhibition Program Director
The Art Museum Association of America

FOREWORD

The notion that an exhibition of Black American art should be organized first occurred to me a number of years ago at the University of Washington. Like most graduate students in the history of art, I spent a great deal of time in the library, and like many of my colleagues in graduate school, I was often drawn to books and periodicals unrelated to my particular field of study. When, on a late fall afternoon, I came across a book by Elsa Fine called *The Afro-American Artist: A Search for Identity*, I was immediately intrigued by what lay inside. What I discovered were a number of artists of whom I had never heard and a tradition that, while parallel to mainstream American art, reflected the uniqueness of the Black experience in the United States. The idea for an exhibition on the history of Afro-American art was thus born, although it would be several years before the project would come to fruition.

In 1984, I had the opportunity to meet David Driskell, Professor of Art at the University of Maryland and one of the foremost authorities on Afro-American art in the United States. Dr. Driskell had been invited to Bellevue to deliver a lecture in conjunction with the exhibition *Afro-American Abstraction*. Over dinner, I told David of my brief encounter with the Fine book and of my interest in organizing an exhibition that would examine the Black contribution to the visual arts in the United States. David discussed his own research on various aspects of Afro-American art and informed me that there had been a tremendous amount of new research in the field since his landmark exhibition and book, *Two Centuries of Black American Art*, had been produced for the Los Angeles County Museum of Art in 1976. Together, we agreed that a smaller exhibition, designed for national circulation, would answer a number of requests he had received for a sequel to the Los Angeles exhibition. At the same time, we agreed that the fruits of his current research would make a significant contribution to the field of American art if a publication were produced to accompany the exhibition and national tour. The next day, I called Hal Nelson, Exhibition Program Director at The Art Museum Association of America, to determine his willingness to organize a national tour for the exhibition, and he enthusiastically agreed.

Hidden Heritage has been designed to present an encapsulated history of Afro-American art over a 150-year period, from the beginning of the nineteenth century to the middle of the twentieth century. The exhibition has not been organized to promulgate the notion that there is a "Black art," for if the visitor were to ask himself what distinguishes a Black artist from a White artist, the answer would be very little, except for those differences that separate any artists. Instead, the exhibition has been designed to call attention to a group of artists who, because of the color of their skin, have tended to be overlooked or ignored by the White art establishment yet have continued to produce a body of work that represents a major achievement in the history of American art. At the same time, the exhibition and accompanying publication have been designed to bring into sharp focus the important contributions these artists have made, and continue to make, to the history of American art.

On behalf of the Board of Trustees of the Bellevue Art Museum, I would like to express my thanks and appreciation to a number of organizations and individuals without whose help the exhibition and accompanying publication would not have been possible.

I would like to express my thanks and appreciation to my friend and colleague David Driskell, who agreed to guest-curate the exhibition and who bore the arduous task of writing the essay for the exhibition catalogue. For the past twenty-five years, David has committed his life to the study of Afro-American art, and I am particularly honored that he would agree to participate in our exhibition and publication.

I am further indebted to the many lenders who agreed to part with their precious objects for an extensive, two-year national tour. Although I cannot thank each one individually here, their names appear in other parts of this book.

The exhibition's initial presentation in Bellevue would not have been possible without the financial support of the PONCHO Foundation, the Hearst Foundation, the Washington State Arts Commission, and the Seattle Chapter of Links, Inc. I am extremely grateful to them for their faith in our ability to plan and implement such an ambitious project.

Special thanks must be directed to The Art Museum Association of America, co-organizer of the exhibition. From the birth of the project almost eighteen months ago, the entire AMAA staff was committed to the notion that an exhibition on the history of Afro-American art must be done. In particular, I would like to thank Lynn Upchurch and Hal Nelson for their ongoing support of the project and Mimi Roberts and Beth Goldberg for their active involvement in the organization and implementation of the exhibition, publication, and national tour.

Finally, and by no means least, I would like to thank the artists whose work is represented in the exhibition. Although their lives were often marked by personal torment and racial prejudice, the artistic legacy which they have left has not been forgotten. Through exhibitions and publications such as this, it is our hope that they will one day take their rightful place in the annals of American art.

John Olbrantz
Director, San Jose Museum of Art
Former Director, Bellevue Art Museum

PREFACE

The notion that an exhibition like *Hidden Heritage* should be undertaken at this time in our history was suggested in the spring of 1984 by John Olbrantz, who had invited me to lecture at the Bellevue Art Museum. During my visit I shared with Mr. Olbrantz aspects of my current research on nineteenth-century Afro-American artists. We agreed that an exhibition highlighting the major works by Black American artists that had not appeared in *Two Centuries of Black American Art, 1750-1950*, which I organized for the Los Angeles County Museum of Art in 1976, would provide an opportunity to add to an area of American art scholarship that has been neglected for too long. We further reasoned that a smaller exhibition comprising painting and sculpture from the nineteenth and first half of the twentieth centuries would be accessible to many deserving museums that have expressed an interest in Afro-American art.

The Art Museum Association of America, whose exhibition program is under the able leadership of Harold B. Nelson, found the idea of this exhibition both desirable and feasible, and I wish to thank the AMAA and Mr. Nelson for their generous support.

Sincere thanks also go to Camille Billops, Jacqueline F. Bontemps, Vada E. Butcher, Camille O. Cosby, Elva Eilertson, Robert Hall, Earl Hooks, Joseph Jacobs, Lois M. Jones, Martha Jones, Stephen L. Jones, June Kelly, Winston Kennedy, Shirley S. Kenny, Janet Levine, Grace Mathews, Keith Morrison, Carlton Moss, Sharon Patton, Delilah Pierce, Stephanie Pogue, Edward L. Shein, Warren Robbins, Luise Ross, and Charles Williams. Each of these persons gave unselfishly of their time and services.

I wish to give special thanks to Guy C. McElroy, whose invaluable research assistance has greatly added to the form and content of this exhibition.

Thanks are also due the Division of Arts and Humanities at the University of Maryland at College Park for its generous funding of my research on nineteenth-century Black artists.

Finally, I am indebted, as always, to my beloved wife, Thelma G. Driskell, for her kind understanding and support. I would like to dedicate this publication to my mother, Mary Lou Cloud Driskell, who is always supportive.

David C. Driskell

Fig. 1
David Bowser
THE BALD EAGLE AND THE SHIELD OF THE UNITED STATES.
1847
Collection Atwater Kent Museum, The History Museum of
Philadelphia, Pennsylvania

Hidden Heritage:
Afro-American Art, 1800-1950

Afro-Americans have been a vital force in American art for nearly three-hundred years, from colonial times to the present. This is true not only in music and dance, where Black contributions are recognized as basic to American creativity, but in the visual arts as well.[1] But it is only in the last forty years, since the early 1940s, that historians have come to appreciate the extent and depth of this Black contribution. The pioneer writings of Alain L. Locke, James V. Herring, James A. Porter, W. E. B. Du Bois, Margaret Just Butcher, and Cedric Dover have been especially important; it was they who first showed Black artists, from eighteenth-century self-taught portraitists to twentieth-century abstractionists, to have been integral participants in the major movements defining the development of painting and sculpture in America.

Porter and later writers have shown that this role in the fine arts grew out of the work of Blacks in the decorative and practical arts in the early eighteenth century. The use of slave labor in both agriculture and industry, which greatly contributed to the economic development of colonial America at the expense of countless Afro-American lives, imbued large numbers of Blacks with such craft skills as carpentry, cabinet-making, pottery, printing, sign-making, metalworking, goldsmithing, silversmithing, and the mechanical arts.[2] Artifactual evidence suggests that Blacks initially combined these new skills with cultural elements they had brought with them from Africa—but also that these African elements were mostly eliminated over time by the oppressive weight of slavery.[3] Nonetheless, the work that survives, by such artisans as the Milton, North Carolina, cabinetmaker Thomas Day and the South Carolina potter known only as Dave, suggests the diversity of skills developed by early Black artisans in America.

Not surprising, then, is the evidence that by the middle and late eighteenth century several Blacks had emerged as practitioners of the fine arts of drawing and painting, distinguished both by their technical facility and by their ability to emulate the popular European styles. Earliest among these were Scipio Moorhead, credited with the portrait of the poet Phillis Wheatley included in the frontispiece of the 1773 edition of her work *Poems on Various Subjects, Religious and Moral*; Neptune Thurston, credited with the early instruction of Gilbert Stuart; and Joshua Johnston, an early Baltimore portraitist.

In Philadelphia, Robert M. Douglass, Jr., a member of a noted Black abolitionist family, also gained distinction as a portraitist, as did his cousin David Bustill Bowser.[4] Douglass was eventually able to study in Europe; Bowser, a landscapist as well as portraitist, is best known as a painter of emblems and banners for Philadelphia fire companies. The image in *The Bald Eagle and the Shield of the United States* (fig. 1) is similar to those he painted for the firemen's hats and banners. Eugene Warburg, a native of New Orleans, was a noted Philadelpia sculptor who eventually settled in Europe.

All these early Black artists developed during a time when American painting and drawing were only beginning to gain recognition through the works of such artists as Benjamin West, John S. Copley, and Charles Willson Peale. They thus demonstrate the early and continuing role of Afro-American artists in the development of American art.

Fig. 2
Joshua Johnston
MOTHER AND DAUGHTER. 1805
Collection Dr. and Mrs. William H. Cosby, Jr.,
Greenfield, Massachusetts

EARLY-NINETEENTH-CENTURY BLACK ARTISTS

How was it possible for people brought to America as slaves to become successful portraitists and landscapists, not to mention cabinetmakers and printers? How did Blacks maintain these positions in an essentially White society? One answer is that, even before the Revolution, in both the North and the South, increasing numbers of Blacks were attaining the status of freedmen or freemen.[5] It was from this class of Afro-Americans, or from slaves who were exposed to their influence, that successful Black artists first developed.

In 1790, it has been estimated that there were 59,000 free Blacks in the United States—about 27,000 in the northern states and 32,000 in the southern states.[6] While most of these lived in rural areas, many lived in major cities like Philadelphia, New York, Baltimore, and Boston.

Some slaves were manumitted after service as indentured servants or in reward for faithful service. Some were freed after their owners' deaths—as, for instance, Willie Lee, George Washington's celebrated slave, who appears attending the President's horse in several post-Colonial paintings. Some purchased their freedom. Others were released because of the family ties that developed when White owners and Black slaves produced children, as they frequently did.

During the Colonial period, when their numbers were relatively small, free Blacks enjoyed a measure of actual freedom in their lives. In the years after the Revolution, however, laws were passed to restrict this freedom: Blacks were required to identify themselves by registering and carrying certificates of freedom. They were prohibited from assembling, from interstate travel, from certain trades, and from "social exchange" between the races. Some states prohibited Blacks from voting; most prevented them from testifying in court.[7]

It was in spite of these growing strictures that some free Blacks managed to prosper. (Some even became slaveholders themselves.)[8] While those in rural areas were engaged in agriculture, those in cities necessarily pursued trades from which the law did not prohibit them. In works examining antebellum America, John Hope Franklin, W. E. B. Du Bois, and others have identified Black tradesmen in all of the major American cities. There were Afro-Americans working as tailors, caterers, ship pilots, grocers, dentists, ministers, teachers, and lawyers, as well as Afro-Americans working in the crafts noted earlier. Success in these trades allowed some Blacks to accumulate a certain amount of wealth, and this wealth in turn allowed them to pursue cultural interests. The ways in which they developed these cultural interests of course mirrored the ways of the European Americans—and, indeed, Black participation in the fine arts was often only an attempt to attain the appearance of culture without an understanding of the profound emancipation of the Black spirit possible through the arts.[9]

Throughout the period after the turn of the century, however, in the years leading up to the Civil War, life for most Black Americans worsened.[10] Following the War of 1812, the growing industrialization of the North diminished interest in slavery there even further than it had been, but the opposite was true in the South, where growth in the cotton industry created a demand for greater importation of slaves. Southern states adopted increasingly restrictive Black Codes, both to control the slave population and to limit the activities of free Blacks. While free Blacks continued to maintain themselves during this period, by the end of the decade preceding the Civil War, their rights hardly exceeded those of slaves.[11]

The contrasting economic pressures increased tensions between the North and the South, tensions that were heightened with the advent of anti-slavery societies and the growth of anti-slavery tracts and journals. This growth of the abolitionist movement, in both the North and the South, particularly after 1830, provided Blacks with important White allies and supporters. The development of an educated and culturally-aware Black population was also promoted by the growth of Black churches and other, secular organizations and by a general increase in Black education, an increase effected through self-help programs and the gradual opening up of schools to Black students.

The achievements of the Baltimore portraitist Joshua Johnston (1765–1830) illustrate the degree to which Black artists could succeed during the period from the 1780s to the 1830s in which he was active.

Despite intensive research, Johnston's origins remain unclear. He has been variously identified as an indentured slave from Philadelphia, a Haitian émigré, or the freed slave of a prominent Baltimorean.[12] He first appears as an artist in Baltimore city directories of the 1820s, where he is listed as a limner or portrait painter. In an advertisement in the Baltimore *Intelligencer* of December 19, 1798, he refers to himself as a "self-taught genius" and describes his talents as such that he could "insure the most precise and natural likenesses" of his sitters. His works reportedly hung in the "best rooms" of Baltimore's society elite in the late eighteenth and early nineteenth centuries;[13] among his commissions were portraits of the city's "civic, military and mercantile families."[14]

Johnston's surviving works—more than fifty have now been attributed to him—demonstrate his awareness of the various popular styles of Federalist portraiture that are also evident in such Baltimore-area contemporaries as Charles Willson Peale and Charles Peale Polk. (It may be that Johnston visited the Peale Museum, established by Rembrandt Peale around 1814.)[15] Johnston painted in a frank and revealing style that manages to capture the nuances of his subjects' personalities while investing them with the dignity and poise appropriate to their social standing. His portraits of children—for example, *Edward and Sarah Rutter* (cat. no. 2)—are particularly appealing. That painting and the other examples of his work here—*Portrait of Isabella Taylor* (cat. no. 3), *Mother and Daughter* (fig. 2), *Gentleman of the Shure Family* (cat. no. 4), and the companion portraits *Baltimore Shipowner* and *Baltimore Shipowner's Wife* (figs. 3 & 4)—exhibit a charming realism, achieved through the naive handling of perspective and proportion, flat background, and special attention to the painting of hair and lace. In the European tradition, his subjects often hold objects indicating their status or possessing some other symbolism; thus, women hold books or letters, and children, the bounty of the womb, hold fruit.

Johnston is considered to be an early naive painter, but his works reveal a sophistication and an understanding of contemporary portrait formulae that go beyond that category. Indeed, they compare favorably with those by such contemporaries as Oliver T. Eddy and Jacob Frymire. Johnston's accomplishments as an artist were reflected in a commercial success that allowed him, through the patronage of Baltimore's upper class, to support himself and his family and even to acquire property—an accomplishment that was neither easy nor usual for a Black man in antebellum America.

The life of Robert Stuart Duncanson (1821/22–1872) illustrates the issues and experiences that confronted the free Black artist in the years just before the Civil War. The first Afro-American to enter fully into the mainstream of American art, Duncanson was a landscape painter of considerable talent, gaining recognition both at home and abroad for his Romantic compositions and his fresh nature studies. Contemporary critics compared him favorably with other artists working in the style of the Hudson River School.

According to an 1853 passport, Duncanson was born in Seneca County, in New York.[16] Like Johnston and several other early Afro-American artists, he was a mulatto; his mother was a free Black, his father a Canadian of Scottish descent. When Duncanson was a child, his father may have taken his family back to Canada, a practice common in the nineteenth century among White men who fathered children by Black women as they attempted to escape the racist strictures in the United States.

By 1841, however, Duncanson was living with his mother in Mount Healthy, Ohio, near Cincinnati, showing works in local exhibitions. He appears to have been self-taught; there is no record of his having received any formal training before this time. In the 1840s and 1850s Duncanson's name appears in several exhibition catalogues and news articles along with artists like Thomas Worthington Whittredge, William Louis Sonntag, Godfrey N. Frankenstein, Miner K. Kellogg, and Thomas Buchanan Read.

Mid-nineteenth-century Cincinnati, a major commercial hub between the North and the South, was an excellent place for the artist to begin his career. Cultural and artistic organizations flourished as collectors and artists began to see the affirmation of national pride in the developing native American art. Cincinnati was also a center of activity for abolitionists, who not only befriended Duncanson but became his supporters and patrons.[17] Noted abolitionists James G. Birney, Lewis Cass, Richard Sulton Rust, and Nicholas Longworth all had their portraits painted by Duncanson.

Duncanson also spent time painting in Detroit and made trips to Michigan, North Carolina, Pennsylvania, and New England. As his skills developed, he received considerable critical praise in Cincinnati and Detroit newspapers. In 1848, he executed a series of murals for Belmont (now the Taft Museum, in Cincinnati), the home of his patron Nicholas Longworth. Widely praised at the time of their completion, the murals testify to the artist's awareness of American and European landscape techniques, combining the realism of the Hudson River School with the Neoclassical tendencies of Claude Lorraine and Nicholas Poussin. The same year, 1848, he also painted *The Catch* (cat. no. 9) and *Man Fishing* (cat. no. 10). *Fruit Still Life* (fig. 5) demonstrates Duncanson's knowledge of the American still life tradition as practiced by the Peale family.

In 1853, Duncanson traveled to Europe, perhaps with the assistance of the Anti-Slavery League. Visiting England, France, and Italy, he was impressed by the works of the English landscapists, particulary Joseph M. W. Turner. In France his interest in the landscapes of Claude Lorraine was reaffirmed.[18] Returning to the United States in 1854, Duncanson executed works of greater maturity, combining an atmospheric quality based upon direct observation of nature with Romantic and Neoclassical characteristics.

The same year, after visiting friends and patrons back in Cincinnati, Duncanson returned to Italy, where he showed a renewed interest in the Claudian approach to landscapes. The ancient buildings in the decaying cities of the Italian countryside fascinated him, serving as subjects for paintings that reveal a steadily advancing technique. His *Landscape with Classical Ruins* (cat. no. 12) and *Italianate Landscape* (fig. 6) combine fantasies about place with romantic notions about landscapes. Duncanson's exceptional skills as a painter led to his citation by an eminent English critic, in 1866, as "the best landscape artist in the west." Acclaim such as this helped generate an admiring audience for him in England and, later, an equally admiring audience back home.

By 1860 the Romantic flavor predominated in Duncanson's landscapes. A continuing interest in Romantic literature led him to paint works based on writings by Tennyson, Walter Scott, and Thomas More. In 1861 Duncanson painted *Land of the Lotos Eaters* (collection of His Royal Majesty The King of Sweden), a fantastic composition based on the Tennyson poem. Of all Duncanson's paintings the one that has gained the most praise, *Land of the Lotos Eaters*, with its flowing waterfalls and misty tropical environment, succeeds in the difficult task of conveying both the image and the spirit of the poem's idyllic paradise.

After the Civil War started, Duncanson spent less time in Cincinnati, which may have seemed too close to the violence and discomforts of war. He traveled and painted in the North, in Canada, and, from about 1865 to 1867, in England and Scotland. On his return to the United States, he resumed his successful and profitable career, working again in Cincinnati and Detroit.

In late 1871 Duncanson became seriously ill and was admitted to the Michigan State Retreat, in Detroit, where he died the next year, on December 21, 1872. Contemporary reports suggest he had lost confidence in himself as an artist, and a letter of his dated June 29, 1871, implies there were family tensions arising from a fear that he would reject his Black origins.[19]

Duncanson's career shows how much Black artists could accomplish in mid-nineteenth-century America. By his own talent and determination, and with the help of sympathetic supporters, he gained international notice and helped dispel negative myths about the ability of Blacks in the arts. Unfortunately, however, because of the ingrained nature of American racism, his achievements were not shared or passed on to younger Black artists. This pattern has remained: each succeeding Black artist has had to face the same tests as Duncanson.

Other Black artists, such as the Philadelphia portraitist Robert M. Douglass, Jr. (1809–1887), the engraver of portraits and landscapes Patrick Reason (1817–ca. 1901),[20] and the Boston portraitist William Simpson (1818–1872) were also reported to be active during the same period as Duncanson. But virtually all their works have been lost, a rare exception being Simpson's *Portrait of Charity Banks* (fig. 10). Many of those by Edward M. Bannister (1828–1901), an important exponent of the Barbizon School in America

Fig. 3
Joshua Johnston
BALTIMORE SHIPOWNER. ca. 1815
Barbara Johnson Collection, Princeton, New Jersey

Fig. 4
Joshua Johnston
BALTIMORE SHIPOWNER'S WIFE. ca. 1815
Barbara Johnson Collection, Princeton, New Jersey

Fig. 5
Robert S. Duncanson
FRUIT STILL LIFE. 1849
Collection Corcoran Gallery of Art, Washington, D.C.,
Museum Purchase, 1968

who is celebrated primarily for his brooding and evocative landscapes, have survived. His career allows us another look at the life of a free Black artist during the middle—and, in this case, the late—nineteenth century.

Bannister was born in St. Andrews, New Brunswick, Canada, to a Black father from Barbados and a White mother born in St. Andrews. He began sketching as a child. As a young man he is believed to have worked as a cook on northeast-coast trading ships. This experience may have reflected or engendered his fascination for the sea—a fascination that manifested itself in his early marine paintings and a life-long love of sailing.

By the 1850s Bannister had left behind the mobile life of a sailor and settled in Boston, even then a noted cultural and intellectual center and a center for anti-slavery activism. Here, in 1831, William Lloyd Garrison had begun publishing his *Liberator*, a virulently abolitionist journal. Here also the New England Anti-Slavery Society lent much needed support to Blacks, and Black community activists such as William C. Nell and Charles Lenox Remond worked to effect change.

Bannister began work in Boston as an unskilled laborer, but he eventually learned the trades of barber and daguerrotypist.[21] In 1854 he married Cristiana Carteaux, a descendent of Narragansett Indians from the Providence, Rhode Island, area. A successful businesswoman, Carteaux was the owner of several local hair salons.[22]

By the late 1850s and early 1860s Bannister had become serious about painting. He may have studied drawing and anatomy with William Rimmer, the noted anatomist and creator of haunting painting and sculpture. Bannister's early work indicates a struggle to gain technical proficiency. But many of his early landscapes, while naive in execution, are nonetheless interesting for their suggestion of panoramic space. By 1864 Bannister's technique had so improved that, when his full-length likeness of Civil War hero Robert Gould Shaw, the leader of a Black regiment, was shown at the Salliers Relief Fair, Bannister received critical praise from the journalist and anti-slavery activist Lydia Maria Child.[23]

Bannister's skill as an artist developed further in the 1860s in Boston, where he painted portraits, landscapes, seascapes, religious scenes, and genre scenes.[24] There is no record of the source of Bannister's style, but the tones and broad brush strokes show an awareness of the free brushwork and palette characteristic of the Barbizon and Impressionist schools.

Beginning about 1870 Bannister concentrated on landscapes, painting in a style that shows an increasing Barbizon influence—an influence that was promoted by the presence in Boston of William Morris Hunt, the most important American exponent of the Barbizon school, and his circle.[25] Bannister and Hunt both exhibited on various occasions at the Boston Athenaeum and the Boston Art Club. In any case, in Boston Bannister could see exhibitions with works by Jean-François Millet, Constant Troyon, Théodore Rousseau, and Charles Daubigny.

Through the work of art dealer Seth M. Vose, Barbizon painting had become popular in Providence, Rhode Island, and in 1871 Bannister moved there, opening a studio and, it is believed, giving lessons.[26] In Providence, Bannister became friends with the leading figures in the local art community. He continued his study of landscapes, painting the rolling meadows and hills surrounding the city in the Barbizon style, interpreting what he believed was God's perfect handiwork imprinting itself on the land.

Bannister did include human figures in his compositions, but they seem small and unimportant in comparison with the vastness and enduringness of nature.[27] Many of his works also show stark contrasts—between, for instance, the peacefulness of the land and the violence of the sea—as Bannister sought to express his reverence for the different ways in which beauty is expressed in nature. Others depict human tragedy in the midst of great natural beauty—a slave, for instance, attempting to escape a bitter life and find an earthly paradise. Here Bannister was engaging in the same unending search for brotherhood, peace, and tranquility and displaying the same religious zeal shown in the works of Thomas Cole and other Hudson River painters.

Bannister gained wider recognition following the award of a bronze medal to him for *Under the Oaks* during the 1876 Philadelphia Centennial. Viewers were reported to be incredulous when they learned

this prize-winning work had been painted by a Black; indeed, an official at first stopped Bannister when he went to claim his prize.[28] In any event, the award reportedly led to the sale of several works to New England households. *Under the Oaks* itself was sold to the Boston collector John Duff for the then-large sum of fifteen-hundred dollars. The painting, now lost for almost a hundred years, is believed to have been Bannister's major work. In its subject *Under the Oaks* was typical of many of Bannister's landscapes painted during the 1870s, in which a stand of oaks provided the main compositional element—for instance, *Oak Trees* (fig. 7).

In the mature works of the 1880s and 1890s, Bannister experimented further with the creation of landscapes that could express spiritual and emotional responses to nature. Still executed in broad brush strokes, they emphasize horizontal planes and patterns of light and dark. Like other American Barbizon painters, Bannister liked to include such details as grazing cattle, rustic cottages, and quietly flowing rivers—all tending to convey a sense of reverie and nostalgia for nature. These elements can be seen in *Landscape Figures and Cows* (cat. no. 17), *Providence Harbor* (cat. no. 15), and *Palmer River* (fig. 8). In the late 1890s, Bannister did experiment with a bright palette, but he nonetheless remained firmly within the Barbizon tradition.

Bannister is reported to have died praying at the Elmwood Avenue Baptist Church. The high esteem in which the Providence art community held him is witnessed by a memorial exhibition mounted in his honor by the Providence Art Club the year of his death.

While all of the above-mentioned artists were active in the East or Midwest, Grafton Tyler Brown (1841–1918) was working as a painter and lithographer in the West. Believed to be the first Black artist in California, Brown also traveled and worked in Nevada, the Pacific Northwest, and Canada. In 1883 he showed twenty-two works in an exhibition in Victoria, British Columbia, including the two local landscapes *Long Lake* (cat. no. 18) and *Above the Gorge* (fig. 9). His style, with its lack of modeling and emphasis on flatness, invites comparison with folk art and early lithography.[29]

Fig. 6
Robert S. Duncanson
ITALIANATE LANDSCAPE. 1855
Collection California Afro-American Museum,
Los Angeles, California

Fig. 7
Edward M. Bannister
OAK TREES. 1870
Collection National Museum of American Art, Smithsonian Institution, Washington, D.C., transfer from Museum of African Art

Fig. 8
Edward M. Bannister
PALMER RIVER. 1885
Collection Mr. and Mrs. Daniel Mechnig,
Providence, Rhode Island

Fig. 9
Grafton T. Brown
ABOVE THE GORGE. 1883
Collection Provincial Archives of British Columbia,
Victoria, British Columbia

Fig. 10
William Simpson
PORTRAIT OF CHARITY BANKS. ca. 1870
Collection Maryland Commission of Afro-American History
and Culture (on extended loan from the History Department
of the University of Maryland), Annapolis, Maryland

LATE-NINETEENTH-CENTURY BLACK ARTISTS

Mary Edmonia Lewis was the first Afro-American artist to reach a broad, popular audience with themes related to her racial origins. This success was probably made possible by the heightened racial consciousness stemming from the Civil War, but it was also related to the growing interest in the Classical and Romantic subjects she favored.[30] She was born between 1843 and 1845, either in New York or Ohio; she died sometime after 1911. Her father was a "gentleman's servant"; her mother, a Chippewa Indian.[31] Her original, Indian name was Wildfire. She described her youth as a happy time growing up in the forests of upstate New York, living with her mother's people, making baskets and embroidered moccasins for sale in nearby cities.

Little else is known about her childhood except that she was orphaned at an early age. In 1859 her brother Sunrise arranged for her to attend Oberlin College, in Ohio, the first college in the country to admit women and one of the first to admit Blacks.[32] It was here that she exchanged the name Wildfire for the Christian name Mary Edmonia. Originally enrolled as a student in the preparatory department's high school course and then as a student in the College's liberal arts program,[33] Lewis reportedly got on well at Oberlin until she became involved in an incredible incident in 1862 that halted her college education for good: she was accused of trying to poison two of her White classmates and put on trial. Defended by the brilliant Black attorney John Mercer Langston, who was also the first Black congressman, Lewis was acquitted, but not before she was brutally beaten by an angry mob.

Leaving Oberlin and moving to Boston in 1863, Lewis decided to pursue a career as an artist, developing a talent she had displayed at Oberlin.[34] With the help of the abolitionist leader William Lloyd Garrison, she began studying with the sculptor Edward Brackett. Progressing quickly, she was soon creating medallions portraying such abolitionists and Civil War heroes as Garrison, John Brown, Charles Sumner, and Wendell Phillips. By 1864 Lewis had her own studio and had executed a bust of General Robert Gould Shaw, the martyred leader of a Black Civil War regiment, of which she sold more than a hundred copies together with a considerable number of John Brown medallions.

These successes helped give her the confidence to pursue the career in sculpture that was her greatest desire and to finance a journey to Europe in 1865.[35] After spending a brief time in Florence, where she visited the American sculptor Hiram Powers, Lewis settled in Rome. There, under the influence of the sculptors Harriet Hosmer and William Wetmore Story, Lewis began working in the prevailing Neoclassical style, though with an emphasis on emotionalism. Her method was first to create a likeness of her sitter in clay, then to cast the work in plaster, and finally to see the work executed in marble.

Many of the works she did during this period show her sensitivity to both her Afro-American and her Indian heritages—as in *The Arrowmaker and Daughter* (fig. 18) and *Forever Free* (cat. no. 20). The latter was a highly successful work depicting the reaction of slaves to the 1863 Emancipation Proclamation. It was a passionate announcement that Black Americans had been released from their bondage and would never be enslaved again. In both features and dress, the two marble figures seem closer to Lewis's Italian models, but there can be no doubt that the work, with its ball and broken chains, was aimed squarely at the American Black audience. It is surely one of the earliest examples of American sculpture to comment directly on the social and political position of Blacks in this country. When it was viewed in America, it received greater attention than any other work by Lewis. By the end of the 1860s Lewis was recognized as one of the most important American sculptors living in Rome.[36]

Throughout the decade of the 1870s, Lewis's fame contined to grow. Drawing on themes from the Bible, classical mythology, and her own heritage, Lewis was able to imbue the Neoclassical idiom with heightened pathos. Her *Death of Cleopatra*, now lost, with its dramatic and natural depiction of the Egyptian queen's death, created a considerable stir when it was exhibited at the 1876 Philadelphia Centennial alongside works by Hosmer and Story.[37] Living in Italy, she traveled and exhibited widely. After an 1873 exhibit of her works in San Jose, California, the Public Library Association obtained a bust of Lincoln and the two works *Asleep* (fig. 12) and *Awake* (fig. 11); all three works remain in the Library's collection.[38]

Fig. 11
Mary Edmonia Lewis
AWAKE. 1872
Collection San Jose Public Library, San Jose, California

Fig. 12
Mary Edmonia Lewis
ASLEEP. 1871
Collection San Jose Public Library, San Jose, California

At the peak of her career, Lewis was as successful financially as she was artistically; the *New Orleans Picayune* reported in 1873 that she had "snared two 50,000 dollar commissions." In the decades following the 1880s, however, as interest in Neoclassicism declined, so did interest in Lewis. But she continued working at least through 1911. The year of her death is uncertain.

The life of Henry O. Tanner (1859–1937) offers an example of a Black artist who flourished in the decades following those of Lewis's greatest successes. While his life spanned the Civil War, Reconstruction, post-Reconstruction, and the New Negro Movement that followed World War I, his career spanned the years in which American artistic taste successively embraced French Academicism and Impressionism and, after 1900, numerous manifestations of modernism.

Tanner was born in Pittsburgh, where his father, the distinguished scholar and minister Benjamin Tucker Tanner, was bishop of the African Methodist Episcopal Church. Tanner became intensely interested in painting as a teenager when he saw a landscapist at work in Fairmount Park, in Philadelphia, to which the family had moved. Trying his own hand at painting, and after taking lessons from two local artists (who, because of Tanner's race, had not been easy to find), Tanner decided he would like to become an artist.

With his family's support, Tanner enrolled at the prestigious Pennsylvania Academy of the Fine Arts in 1880. Studying there for two years with Thomas Eakins, considered by some to be America's finest portraitist, he developed an exceptional ability for drawing the human form along with an interest in painting scenes from everyday life.

His early attempts to forge a professional career were disappointing. Unable to establish himself as an artist in Philadelphia, Tanner moved to Atlanta in 1888 and opened a photography studio. When this failed, he obtained a teaching position through the efforts of Bishop and Mrs. J. Crane Hartzell.

It was the Hartzells who in 1891, by purchasing an entire exhibition of his works, helped Tanner attain his longstanding desire to study in Europe, thereby escaping the social and racial inequities that characterized post-Reconstruction America. This was a crucial point in Tanner's life: through luck and hard work, he quickly gained in France the acclaim and patronage that had escaped him in the United States.

Settling in Paris, Tanner sketched at the Louvre, joined the American Art Club, and enrolled at the Académie Julian, where he studied with Jean Joseph Benjamin-Constant and Jean Paul Laurens. At the Académie he worked to perfect his technique and further developed his interest in genre painting—completing, in 1894, one of the most impressive masterpieces of American genre painting, *The Thankful Poor* (fig. 17 and back cover). Around the same time he traveled in Brittany, where he was inspired to paint *The Bagpipe Lesson* (cat. no. 24), which was based on his Black genre composition *The Banjo Lesson* (collection of Hampton University).

In Paris Tanner enjoyed the artistic and commercial success that had escaped him in the United States. He regularly exhibited at the Paris Salon beginning in 1895. His work *Daniel and the Lion's Den* received an honorable mention in 1896. A brooding work with dramatic light effects, it appears to have been influenced by Rembrandt. (The original and a second version are both lost, but a third version, executed around 1916, is now in the collection of the Los Angeles County Museum of Art.)[39] Meanwhile, his works sold well, he began to receive the support of wealthy French patrons, and art institutions back in America began to notice him. He won purchase prizes at the Lousiana Purchase Exposition in 1904 for *The Good Shephard*; the Carnegie Institute Annual in 1905 for *Christ at the Home of Mary and Martha*; and The Art Institute of Chicago in 1906 for *Two Disciples at the Tomb*. All these works remain at these institutions.

In 1898 Tanner married Jessie Macauley Olssen, a White woman from San Francisco, who became the model for many of his works, including *Christ and His Mother Studying the Scriptures* (fig. 13).[40] Their son Jesse is the young Christ in the painting.

Gaining increasing attention and honors, Tanner received a medal at the 1897 Salon for *The Raising of Lazarus*, which was purchased by the French Government and is now in the Luxembourg Gallery. Around this time his paintings grew lighter as he made frequent trips to northern Africa and the Holy

Land. He also employed a method of painting using thin glazes to give his works unusual depth and luminosity. In *The Disciples on the Sea* (fig. 16) and *Christ Walking on the Water* (cat. no. 27), Tanner uses this technique and omits unnecessary detail to capture the vibrancy of the light he found in the Middle East. In *The Destruction of Sodom and Gommorah* (cat. no. 28) he masterfully depicts this light filtered through smoke billowing from the burning cities.

Tanner's success was an important symbol to Blacks back in America. But Tanner deliberately rejected requests to return to the United States to help in the development of an American school of Black art because of the deep prejudice he had found there and because he saw himself simply as "a man and artist living and working in a free society."[41] Though he informally gave instruction to the Black artists who visted him, he founded no school or circle that might have generated a lasting Black movement in the arts.

Tanner never lost the deep sense of religion he had gained growing up in a minister's home, and as his success grew he devoted himself to mastering the art of religious painting. But even within this religious framework Tanner's work continued to incorporate a structure solidly based on a close examination of life. Each of his paintings strives to convince the viewer that he or she is part of the scene depicted. Throughout his body of work, Tanner reveals a sure knowledge of the need for balance between art that belongs to the social order and art that lifts the viewer to a higher plane.

Two of Tanner's students in Paris were William A. Harper (1873–1910) and William E. Scott (1884–1964). During his brief life Harper worked mainly in a style influenced by Claude Lorrain and the Barbizon School, as demonstrated by his work *Landscape with Poplars (Afternoon at Montigny)* (fig. 14). Scott, a painter, illustrator, and muralist, was a sensitive observer of scenes from everyday life. The mural sketch *Haitian Market* (fig. 15) derives from a trip Scott made to Haiti in 1931 on a Rosenwald Foundation grant.

Tanner's great success showed the heights to which a Black artist could aspire at the turn of the century, but his expatriate status underlined the problems that would present themselves to any Black aiming for achievement in the fine arts in America. Nonetheless, the late nineteenth century produced a number of successful Black artists—artists who form a transition from the world of Reconstruction and post-Reconstruction to the Harlem Rensaissance of the 1920s and the surge of creativity stimulated by New Deal programs in the 1930s and early 1940s.

The sculptor Meta Vaux Warrick Fuller (1877–1968) was one of the most important figures in this transitional period. She was born in Philadelphia to a Black middle-class family. Her father was a barber and, later, a successful caterer; her mother, a beautician with clients among Philadelphia's upper class. They groomed Fuller to be a lady of culture from the very beginning. Attending Philadelphia's Black segregated schools and the Pennsylvania School of Industrial Art,[42] she was recognized for her unusual artistic talent, receiving first prize for a metal crucifix at her graduation.

In 1899 Fuller traveled to Paris, where she studied at the École des Beaux-Arts and the Académie Colarossi. She remained in France three years, developing a style akin to Rodin's, with its fusion of real and ideal. Rodin reportedly viewed her works, mixing praise with harsh criticism.[43] In 1902 Samuel Bing, owner of the prestigious gallery L'Art Nouveau, arranged for her to exhibit at his gallery. Among the works shown were *The Primitive Man*, *Head of a Man*, *The Sphinx*, and *Portrait of a Dead Man*—all of which were either destroyed in a 1910 studio fire or may be assumed to remain in private collections.[44]

When Fuller returned to Philadelphia, galleries rejected her works on account of her race.[45] In 1907 she married Dr. Solomon Fuller and moved to Framingham, Massachusetts, near Boston. In the later years of her career, she showed an increasing interest in depicting Black Americans, as in *Water Boy* (fig. 20).

One of her most powerful images is *Ethiopia Awakening* (fig. 19), produced in two versions—one a life-size piece made out of plaster; the other, exhibited here, a smaller version cast in stone and plaster. The figure emerging from swaddling symbolizes the birth of cultural and social emancipation in America and the beginning of the end of colonial rule in Africa.[46] Executed just before the beginning of the Harlem Renaissance, it seems to foretell that movement's burst of creativity.

Fig. 13
Henry O. Tanner
CHRIST AND HIS MOTHER STUDYING THE SCRIPTURES. n.d.
Collection Dallas Museum of Art, Deaccession Funds/
City of Dallas

Fig. 14
William A. Harper
LANDSCAPE WITH POPLARS (AFTERNOON AT MONTIGNY),
ca. 1898
Collection Gallery of Art, Howard University,
Washington, D.C.

Fig. 15
William E. Scott
HAITIAN MARKET. 1950
Collection Fisk University Museum, Nashville, Tennessee

Fig. 16
Henry O. Tanner
THE DISCIPLES ON THE SEA. ca. 1910
Collection The Toledo Museum of Art, Toledo, Ohio,
gift of Frank W. Gunsaulus

Fig. 17
Henry O. Tanner
THE THANKFUL POOR. 1894
Collection Dr. and Mrs. William H. Cosby, Jr.,
Greenfield, Massachusetts

Fig. 18
Mary Edmonia Lewis
THE ARROWMAKER AND DAUGHTER. ca. 1872
Collection Tuskegee Institute, Tuskegee, Alabama

Fig. 19
Meta Vaux Warrick Fuller
ETHIOPIA AWAKENING. n.d.
Collection Meta Warrick Fuller Legacy, Inc., Framingham, Massachusetts

Fig. 20
Meta Vaux Warrick Fuller
WATERBOY #1. 1930
Collection Meta Warrick Fuller Legacy, Inc.,
Framingham, Massachusetts

EARLY-TWENTIETH-CENTURY BLACK ARTISTS

At the turn of the century, industrialization was fast concentrating wealth in the nation's cities, and the United States was changing from a predominantly rural to a predominantly urban society. Blacks as well as Whites were joining in this movement in their quest for employment, and despite their continued exclusion from many businesses, trades, and unions Blacks formed large communities in both northern and southern cities—a trend that was to intensify later in the century, after the first World War.[47] This concentration of Blacks engendered a sense of social, if not political and economic, security that expressed itself in a flourishing subculture, especially in New York, Chicago, Washington, and Baltimore.

The fact that some Blacks in the late nineteenth century were allowed to receive formal training at prominent American art institutions and were able to follow this training with study in Europe shows the extent to which opportunities for Blacks were increasing despite racial oppression. Though the end of Reconstruction in the 1890s spelled the end to many laws designed to protect Blacks in the South, and though, as noted, businesses and unions both tried to exclude Blacks from good jobs, a Black middle class continued to grow in the cities. This growth was often based on service-oriented businesses.

Black institutions of higher education that had been founded after the Civil War—for example, Howard, Fisk, Hampton, and Atlanta Universities—received a fresh influx of support from philanthropic organizations like the General Education Board, the Peabody Education Fund, the Phelps-Stokes Fund, and the John F. Slater Fund.[48] Increasing numbers of Blacks attended predominantly White schools.

Across the United States, Blacks met in regional and national congresses to define strategies for improving their conditions and to counteract the effects of sometimes violent racial conflicts. Secular and religious organizations providing vital social services and pressing for the rights of Blacks in the courts multiplied. The National Association for the Advancement of Colored People was organized in 1910; the National Urban League, in 1911. The aggressive stance of Marcus Garvey's United Negro Improvement Association, founded in 1914, led to an increase in Black pride, especially among the working class. Black authors documented the Black experience in an increasing number of publications, and interest in Black music, literature, dance, and visual arts grew in proportion to the growth of an enlightened, sophisticated middle class. The issue of Black equality acquired even greater urgency with the return of Black soldiers from the Great War.

By 1923 New York's Harlem, which had the largest Black population of any city in the United States, could count 300,000 persons of African descent within its borders. The promise of employment and a convivial life in a Black metropolis combined with real estate speculation to produce extremely rapid growth. Serving the growing populace was a highly visible middle class comprising merchants and professionals. The stage was thus set for the outpouring of creativity that followed.

Music and dance were the first Black art forms to enter the mainstream of American culture. This crossover began in the early years of the century, when ragtime and jazz, along with the cakewalk and the fox trot, gained widespread popularity, as White performers and entrepreneurs like Carl Van Vechten, Charlotte Mason, and Mable Dodge went uptown to hear the music featured by Black establishments in Harlem.[49] There, they mingled with Black intellectuals like composer Rosamund Johnson; his brother, the writer James Weldon Johnson; composer Harry T. Burleigh; art patron Bob Cole; educator William Marion Cook; band director Jim Europe; and poet Paul Laurence Dunbar. These exchanges, coupled with the creative entrepreneurship of Black businessmen, fostered the early Black musicals that laid the groundwork for an outburst of musical and dramatic energy that led up to the years of the Harlem Renaissance.

As Blacks and Black culture became more conspicuous in American life, they became increasingly interesting to sociologists and others seeking to understand the effects of massive industrialization on American society. To some of these authors—Frank Tannenbaum, for example, in *Darker Phases of the*

South and Robert Kerlin in *Voice of the Negro*—the position of Blacks symbolized the deleterious effects of the change from rural agricultural to urban industrial life. Dramatists too probed the Black experience; Eugene O'Neill's *Emperor Jones* (1920) and *All God's Children Got Wings* (1924) brought the forceful presence of Paul Robeson onto the stage, and Paul Green won a Pulitzer prize for his 1929 work *In God's Bosom*, which used a predominantly Black cast.[50]

During these years Harlem offered a measure of independence and opportunity not found elsewhere. In reaction to the slipping fortune of Blacks in the nation as a whole, a large group of Black intellectuals believed they could take advantage of the opportunities Harlem offered to generate an artistic revolution that would stimulate and advance social and cultural interests of Blacks throughout the country. Among the many participants in this effort, W. E. B. Du Bois, Alain L. Locke, and Charles Spurgeon Johnson stand out.

Du Bois, a Harvard-trained sociologist, was the editor of the NAACP publication *Crisis* during this period. Johnson, a University of Chicago sociologist, was the director of research and investigation for the National Urban League and the editor of its journal *Opportunity*. Locke, also Harvard-trained and the first Black Rhodes Scholar, was a professor of philosophy at Howard University and a particular champion of Black visual arts.

Du Bois had called for an emphasis on Black art as early as 1910 in *Crisis*. In the years that followed, he continued to speak of the needs of Black artists and joined an increasing number of editors publishing works by Black writers. Taking full advantage of this new opportunity, Black writers like Claude McKay, Jean Toomer, Jessie Fausett, Countee Cullen, Langston Hughes, and James Weldon Johnson instilled new consciousness of the Black experience in the American public.[51]

THE NEW NEGRO MOVEMENT

Into the mid and late 1920s, as James Porter has shown, Black visual artists lacked the same kind of opportunities and successes as Black literary artists.[52] Their few, irregular exhibits were often supported solely by the Black intellegentsia plus a few White supporters.[53] In part this was simply one aspect of the dilemma in which virtually every American painter found him or herself; as the art historian E. P. Richardson put it: "The patrons of conservative tastes remained faithful to the older men of the National Academy of Design, while the patrons of advanced taste preferred to buy European paintings rather than American."[54] In part, however, the situation in which Black visual artists found themselves *was* due to their race, which denied them access to adequate patronage and ostracized them from the larger art world.

The Harlem Renaissance, or New Negro Movement, of the 1920s provided the much-needed system of support. As early as 1924, the staff of the *Crisis* began administering the Amy Springard prizes, which were cash awards to promising writers and visual artists. From 1927 to 1933, the Harmon Foundation Exhibits also served as an important stimulus to Black artists.[55]

Moreover, during these years individual Black artists finally began to receive encouragement and support—primarily from those who saw themselves as patrons of the Harlem Renaissance. These men and women had a set of definite ideas about the role of the Black artist in the new Black society they were trying to create and about the kind of art that should be produced. Du Bois and Locke, among others, urged Black artists to consciously celebrate the Black lifestyle.[56] Locke emphasized the importance of African art to the development of Black artists; in his book *The New Negro* he included a chapter entitled "The Legacy of Ancestral Arts."

With this encouragement and support, Black artists were increasingly in a position to create significant works of art, both in the conservative styles still prevalent in the United States and in the styles promoted by the New Negro Movement, and in a position to see these works exhibited and purchased.

Sargent Johnson (1887–1967) was among a group of older Black artists who began to seek out African sources for their paintings and sculpture. Works like *Mask: Young Girl with Golden Braids* (cat. no. 32) and *Woman's Head* (fig. 21) show the extent of this change—in both form and content—from the works of artists working according to conventional traditions.

Most artists involved in the early stages of the New Negro Movement—painters like Aaron Douglas, Archibald Motley, Jr., Palmer Hayden, and Malvin Gray Johnson—began their careers painting in the Academic or Impressionist styles then current. In response to the new view of their role as Black artists, and in accordance with their own, personal visions of Black life and culture, these styles underwent a process of evolution toward the primitive or naive.

Aaron Douglas (1899–1979) was the first Black artist to follow Locke's advice to reach back to his African sources. He began his career as an apprentice to the illustrator Winold Reiss in New York, where he had moved from his native Kansas City at the urging of Charles Spurgeon Johnson. For his illustrations, which appeared in issues of *Crisis* and in James Weldon Johnson's 1927 work *God's Trombones*, Douglas developed a style that combined the linear rhythms of the Art Nouveau and the Art Deco with angular, Cubist elements. With their flat tones, they conveyed the rhythms of African music and dance. For his portraits he used Impressionist techniques to produce brilliant character studies. He also painted landscapes. But his most significant works were the murals he painted in 1934 for the Countee Cullen Branch of the New York Public Library. Painted in his rhythmic, geometric style, they consist of four thematic panels entitled *Aspects of Negro Life*. Inspired by the theories of Du Bois and Locke, the works recount the painful story of Blacks in America from slavery to freedom and from rural to urban life. Two studies for these panels—*Study for Aspects of Negro Life (from Slavery through Reconstruction)* (fig. 25) and *Study for Aspects of Negro Life (Idyll of the Deep South)* (cat. no. 49)—are included in this exhibition. Two other works by Douglas—*Noah's Ark* (fig. 26) and *Go Down Death* (cat. no. 50)—exemplify his unique style combining African elements and the modernist aesthetic of the 1920s.

Fig. 21
Sargent Johnson
WOMAN'S HEAD. n.d.
Collection San Francisco Museum of Modern Art,
San Francisco, California, Albert M. Bender Collection,
bequest of Albert M. Bender

As the first artist to explore his Black heritage in the context of contemporary painting, Douglas was dealt with harshly by critics, who accused him of relying too heavily on the literal use of African themes. But Douglas was a crucial figure in the early Harlem Renaissance, a pioneering Africanist who paved the way for Blacks—first in Harlem and then throughout the United States—to see themselves as acceptable subjects in art.[57]

Ellis Wilson (1899–1977), represented here by *Shore Leave* (fig. 24), though less well known than Douglas, was also an early painter of Black subjects. Many of his other paintings are exotic color compositions depicting ordinary people of the Carribean islands, southern Blacks as field hands, and the flora and fauna of those regions.

Archibald Motley, Jr., (1891–1980) and Palmer Hayden (1893–1973) also responded warmly to the ideas of Du Bois and Locke early in their careers.

Motley was born in New Orleans and studied at the Art Institute of Chicago. Exhibited as early as 1928 at New Galleries in New York, and a recipient of a Harmon Foundation award, he worked simultaneously in two styles. In one he created fascinating realist studies of Black characters—as in *Mending Socks* (fig. 23); in the other he created brilliantly colored, bizarre, and fantastic compositions that evoked African tribal rites or voodoo rituals.

Later in his career Motley focused on painting witty scenes of sophisticated life in Harlem and other Black American communities, as well as in Paris. With their rich, colorful depictions of Black city-dwellers at play, works like *Black Belt* (fig. 28) and *The Jazz Singers* (cat. no. 41) perhaps went further than Locke foresaw when he urged Black artists to focus on Black culture. In any event, Locke criticized Motley for his "somewhat lurid color scheme" with its "emphasis on the grotesque and genre side of modern Negro life."[58]

Hayden came to focus on Black subjects a little later in his career. Born in Wide Water, Virginia, he first studied at Cooper Union and later at the art colony at Boothbay Harbor.[59] He moved to Paris in 1927, where he studied at the École des Beaux-Arts. He won the John D. Rockefeller Prize for Painting in 1933.

Like many Black artists who preceded and followed him, he was strongly influenced by the Impressionist palette. Two works from the late 1930s—*Midsummer Night in Harlem* (fig. 29) and *When Tricky Sam Shot Father Lamb* (cat. no. 44)—depict scenes from everyday life in a somewhat satirical style that is nonetheless imbued with empathy for their subjects. The inspiration for *When Tricky Sam Shot Father Lamb* is said to have been a shooting that Hayden witnessed one Saturday night in a small town.

In the years that followed Hayden began to use themes derived from Black folklore and mythology, as in his *John Henry* series (1944–1954). *Big Bend Tunnel* (fig. 30) is one of the paintings from this series. Hayden's interest in these subjects paralleled a general interest in folk and regional art during the 1930s.

Malvin Gray Johnson (1896–1934), like Douglas, Motley, and Hayden, also explored Black subjects in his paintings, but in a style that went further toward the modern—as in *Elks Marching* (fig. 27). He studied at the National Academy of Design, where he learned to work in the Academic tradition. But, as he grew familiar with Impressionism and Cubism, he began, in his works of the late 1920s and early 1930s, to emphasize flat planes and bright, Fauvist colors.[60] In 1929 he won a Harmon Foundation prize for a work based on the Negro spiritual "Swing Low, Sweet Chariot."[61]

Johnson's most successful works employ rhythmic lines and contrasts of brilliant light with darkness to create a visionary effect. They project a dynamism found in the Cubist-inspired works of Charles Demuth and Joseph Stella. Later in his career, Johnson focused more and more on the depiction of scenes from everyday Black life.

Unlike Douglas, Motley, Hayden, and Johnson—who adopted their neo-primitive styles in response to the New Negro Movement after considerable study and work in the Academic, Impressionist, or Cubist traditions—Horace Pippin (1888–1946) came to his primitive style naturally. Entirely self-taught, he returned to the United States from France in 1920—not after studying at an academy of art but after fighting in the trenches as part of a Black regiment during the Great War. With his right arm incapacitated from wounds he had suffered, Pippin was forced to devise his own unique method of handling a

Fig. 22
Elizabeth Prophet
SILENCE. n.d.
Collection Museum of Art, Rhode Island School of Design,
Providence, Rhode Island, gift of Miss Ellen D. Sharpe

Fig. 23
Archibald Motley, Jr.
MENDING SOCKS. 1924
Collection North Carolina Museum of Art,
Raleigh, North Carolina

Fig. 24
Ellis Wilson
SHORE LEAVE. n.d.
Aaron Douglas Collection, Amistad Research Center,
New Orleans, Louisiana

brush. When he perfected this technique in 1929, Pippin began to produce the paintings that eventually brought him widespread attention and acclaim.

The *John Brown* series, which culminates in the painting *John Brown Going to His Hanging* (front cover), was based in part on a first-hand account related by his mother, who as a young slave in 1859 had witnessed the abolitionist's trial.[62] The feeling evident in the *John Brown* series is also evident in Pippin's many works dealing with military subjects, such as *Barracks* (fig. 31). These paintings, as well as paintings on everyday, domestic, or religious themes, such as *Harmonizing* (fig. 32) and *Saying Prayers* (cat. no. 35), embody Pippin's unique combination of emotion and introspection on the one hand and simplified flat forms, unusual juxtapositions of color, and lack of modeling and perspective on the other. All these elements caused Pippin's works to be highly esteemed by contemporary exponents of modernism.

Like Pippin, the sculptor Elizabeth Prophet (1890-1960) also worked outside the mainstream of the burgeoning Black art movement, spending most of her professional life in Rhode Island. Taking to African subjects early in her career, she later expanded her interests to include Black American portraiture. She worked in a style that was basically realistic, as shown in *Silence* (fig. 22), but with tendencies toward Expressionism.

Fig. 25
Aaron Douglas
STUDY FOR ASPECTS OF NEGRO LIFE (FROM SLAVERY
THROUGH RECONSTRUCTION). 1934
Collection Stephanie E. Pogue, Hyattsville, Maryland

Fig. 26
Aaron Douglas
NOAH'S ARK. ca. 1927
Collection Fisk University Museum,
Nashville, Tennessee

Fig. 27
Malvin G. Johnson
ELKS MARCHING. 1931
Aaron Douglas Collection, Amistad Research Center,
New Orleans, Louisiana

Fig. 28
Archibald Motley, Jr.
BLACK BELT. 1934
Collection Hampton University Museum, Hampton, Virginia

Fig. 29
Palmer Hayden
MIDSUMMER NIGHT IN HARLEM. 1938
Collection Museum of African American Art, Los Angeles,
California, Palmer C. Hayden Collection, gift of
Miriam A. Hayden

Fig. 30
Palmer Hayden
BIG BEND TUNNEL, from the "Ballad of John Henry" series.
1944-54
Collection Museum of African American Art, Los Angeles,
California, Palmer C. Hayden Collection, gift of
Miriam A. Hayden

Fig. 31
Horace Pippin
BARRACKS. 1945
The Phillips Collection, Washington, D.C.

Fig. 32
Horace Pippin
HARMONIZING. 1944
Collection Allen Memorial Art Museum, Oberlin College,
Oberlin, Ohio, gift of Mr. and Mrs. Joseph Bissett

Fig. 33
Hale Woodruff
THE CARD PLAYERS. 1930
Collection Mr. and Mrs. John H. Hewitt,
New York, New York

THE EARLY NINETEEN-THIRTIES

As we have seen, some Black artists in the 1920s and 1930s experimented with Impressionism and Cubism, but most remained tied to the Realist vision. In this they were consistent with most American painters active during the early decades of this century, beginning with the Ash-Can School, which at the urging of Robert Henri had rejected Impressionism in favor of the depiction of everyday life of American cities, using heavy brushstrokes and a more somber palette.[63] With the coming of the Great Depression, and in reaction to internationalist styles, the American Scene painters again urged American artists to focus on the realistic depiction of American life and history. For Blacks, this meant the realistic depiction of *Black* life and history, a point Alain Locke reiterated in his work *Negro Art: Past and Present*, published in 1936.[64] Working against this injunction, however, were two factors: first, the warning, from James Porter and others, that Black artists should guard against trying to develop an art that was "biologically" Black or that simply sought to imitate African art;[65] and, second, the steadily growing influence of modernism.

After the crash of 1929, as much of the support that had been available for Black artists dried up, the continued support of the Harmon Foundation and new support from Roosevelt's Work Projects Adminstration—the WPA—were crucial to the survival of Black art. Just like their White counterparts, Black artists active during the 1930s worked on murals, operated art centers, and participated in WPA easel projects. *The Blue Jacket* (fig. 34), for instance, was painted by Charles Sebree (1914–1985) in 1938 while he was employed by the Easel Division of the Illinois Federal Art Project. Black art centers opened in Harlem, Chicago, and other cities.[66] Artists who reached maturity during the early 1930s as well as artists from the early Harlem Renaissance both benefited from this long period of government support. The list of artists who participated in WPA and other government projects includes most of the important Black artists active in the decades that have followed.

The sculptor Augusta Savage (1900-1962) was one of these artists. She was born into an impoverished Florida family, but with the help of a family friend she was able to move to New York and enroll at the Cooper Union in 1921. In 1929 she received a Julius Rosenwald Fellowship that allowed her to study in Paris with Felix Beuneteau at the Académie de la Grande Chaumière. During her three years in France she exhibited in several major shows.[67]

Returning to the United States in 1932, she first taught art classes in Harlem and then, with Carnegie Foundation funds, founded the Savage School of Arts and Crafts. Among the notable artists who received their introduction to art at her school were Norman Lewis, Ernest Crichlow, and Jacob Lawrence.[68]

Savage's most successful work was the bronze bust of a street urchin entitled *Gamin* (fig. 36). Carefully modeled, it vividly captures the tough-innocent look of New York street youth. In 1939 Savage created the sculptural ensemble *Lift Every Voice and Sing*, an allegory of Black music that captured the essence of the Rosamund and James Weldon Johnson song. Cast in plaster, the work was destroyed after its exhibit at the 1939 New York World's Fair.

Other Blacks who found outlets for their art in the WPA included Charles Alston (1907–1977) and Norman Lewis (1909–1979). Alston's work oscillated between figuration and abstraction throughout his career. *Farm Boy* (fig. 35) is characteristic of Alston's figurative style and his interest in Black subjects. Lewis's paintings during the early and mid 1930s were explicitly social and political in content, but, while he continued to be active politically, his works in the late 1930s and early 1940s increasingly tended toward abstraction, as in *Jazz Musicians* (fig. 47).[69]

Some artists were able to support themselves during the Depression outside the framework of New Deal social programs like the WPA. Hale Woodruff (1901–1980) was among those who found positions in the academic world. He began his study of art at the John Herron Art Institute in Indianapolis. Receiving a Harmon Foundation Award in 1926, he traveled to Europe to study with Henry O. Tanner at the Académie Scandinave and the Académie Moderne, where, like many others, he was strongly attracted to

Fig. 34
Charles Sebree
THE BLUE JACKET. 1938
The Evans-Tibbs Collection, Washington, D.C.

Impressionism.[70] *The Card Players* (fig. 33) shows Woodruff's interest in European modernism in its subject matter, its Cubist space, and its references to African sculpture. In 1931 he joined the staff of Atlanta University.

As a teacher, Woodruff is noted for having organized the Atlanta University Annual Exhibitions. As an artist, he is best known for *The Amistad Murals* at Talladega College. Completed in 1939, they depict the 1839 revolt of African slaves aboard the Spanish ship *Amistad*. With their vigorous composition and strong color, they owe much to the Mexican muralists Diego Rivera and José Clemente Orozco, who were both active in the United States during the 1930s.[71] Later in his career Woodruff's interests shifted toward Abstract Expressionism. In this style, with the art of Black Africa as his inspiration, he created works of great force and beauty.

James L. Wells (b. 1902) also worked as a teacher—at the Harlem Library Project for Adult Education—after studying art at Lincoln and Columbia Universities and the National Academy of Design. During the 1930s he painted religious works that possessed (in the words of James Porter) an "effect of meditativeness and ecstatic revery."[72] *Journey to the Holy Land (Egypt)* (fig. 38) is typical of Wells's Biblical themes and Expressionist style with a tendency toward two-dimensionality. In the decades that followed he devoted himself to printmaking. At this he was a virtuoso, creating a large body of work with simple but powerful images based on religious and African themes. Often composed of layer upon layer of brilliant color, they show a debt to both German Expressionism and Cubism.[73]

William Henry Johnson (1901–1970) was also drawn to simplified forms and brilliant colors. He arrived in New York from Florence, South Carolina, in 1921 to study at the National Academy of Design with Charles Hawthorne. During the summers, he studied at the Cape Cod School of Art in Provincetown, Massachusetts. Winning several awards at the Academy, Johnson traveled to Paris in 1926, where he came under the influence of the rigorous structuralism of Cézanne, the painterly emotionalism of Van Gogh, and the bright colors and Expressionist style of Chaim Soutine.

By 1928 he was painting works with exaggerated and twisted forms that imbued his subjects with vibrant emotion. In 1930, having returned to New York, Johnson won a Harmon Foundation gold medal in an exhibition at the International House.[74] The jurors were Meta Warrick Fuller, George Helman, Victor Perard, Karl Illaua, and George Luks. During this period Johnson also paid a visit to his home town of Florence, South Carolina, where he painted local subjects.[75]

Returning to Europe, he married the Danish designer and ceramicist Holka Krake; together they settled in the Danish city Kerteminde.[76] There, as well as on trips to places such as Norway and North Africa, he continued to develop his Expressionist style.

In 1938 Johnson and his wife moved to New York, where his style underwent a radical transformation—to a naive approach based on broad areas of flat, brilliant color and primitive, childlike forms. The themes for these paintings ranged from everyday rural and urban life to folk-inspired views of religious subjects—as in *Swing Low, Sweet Chariot* (fig. 44). In particular, Johnson created a series of powerful paintings depicting Christ and his disciples as Blacks—for instance, *Jesus and the Three Marys* (cat. no. 58). While James Porter dismissed the works as "grotesque,"[77] New York critics hailed Johnson's style as "innovative."[78]

After the death of his wife in 1943, Johnson's work, as well as his health, deteriorated. He lived out his last years in a mental hospital on Long Island, New York.

Other Black painters widely recognized during the 1930s and 1940s included Richmond Barthé (b. 1901), Beauford Delaney (1901–1980), and his brother Joseph Delaney (b. 1904). Barthé's dignified portrayals of Black subjects, like *The Negro Looks Ahead* (fig. 37) and *Birth of the Spirituals (Singing Slave)* (cat. no. 56), drew praise from White and Black audiences for the manner in which they appeared to capture in a single image the hopes and aspirations of an entire people. Beauford Delaney's *Street Scene* (fig. 46), painted while the artist lived in New York City, shows the exuberant style by means of which Delaney was able to convey on canvas the energy of city life using vibrant colors and thickly-impastoed

Fig. 35
Charles Alston
FARM BOY. 1941
The Atlanta University Collection of
Afro-American Art, Atlanta, Georgia

pigment. Joseph Delaney used his Expressionist style to paint numerous crowd scenes, such as *Penn Station at War Time* (fig. 39), in which the subject is painted with energy and feeling but without sentimentality.

Selma Burke (b. 1900) worked in both traditional and modern styles. Intimately involved with the Harlem Renaissance through her marriage to the Black writer Claude McKay, she had originally pursued a career in nursing at the insistence of her parents. In 1933, however, she received a fellowship to attend Columbia University, from which she received a masters degree in art. In Europe she then studied sculpture with Maillol in Paris and Povolney in Vienna and had private lessons with Matisse.[79] The modern, Expressionist style she learned from them can be found in works like *Temptation* (fig. 40). In her numerous portrait commissions, however, she adopted a more conservative style reminiscent of Augustus St. Gaudens and exemplified in her 1944 portrait plaque of Franklin D. Roosevelt, now seen on the face of the dime. In 1968, in an effort to introduce more Black youths to art, she founded the Selma Burke Art Center in Pittsburgh.

Another Black sculptor whose work showed the influence of the Harlem Renaissance, though he resided in Chicago during its flowering, was Marion Perkins (1908–1961). Both African and European influences by way of Brancusi, whom he admired, are evident in *The Kiss* (fig. 41).

Two other important Black artists who reached maturity during the early 1930s also had great impact on aspiring Black artists through their roles as educators and promoters in the visual arts—James Porter (1905–1970) and Lois Mailou Jones (b. 1905). Along with James A. Wells, they both helped mold the philosophy and direction of the nation's first Black school of art, at Howard University, to which they had come at the invitation of the art historian James V. Herring.[80]

Porter, an art historian as well as a painter, received a Rockefeller Foundation grant in 1935 to study in Europe. In 1943 he published *Modern Negro Art*, which formed the basis for most modern scholarship on Black art—African, Afro-American, and Afro-Brazilian. From 1953 until his death, in 1970, he chaired the department of art at Howard. At the University's art gallery, he gave exposure to a whole generation of Black artists.

As an artist, Porter was a skilled painter indebted to French Impressionism and Fauvism—as exemplified in *Cuban Bus* (fig. 43).[81] He also executed a series of still lifes and landcapes in which he employed the fluid line and bright light of Matisse.

Jones began her career as a designer but quickly moved to painting. She graduated from the Boston Museum School of Fine Arts and studied at Columbia and Howard Universities and, in Paris, at the Académie Julian and the École des Beaux-Arts. Following a tour of France and Italy in 1938, she exhibited Impressionist-inspired works at Boston's Vose Galleries. Working on Martha's Vinyard during the war years, Jones perfected a style that drew on Impressionism but reflected her own sensibility—as in *Jennie* (fig. 42), an empathetic genre portrait of a Black woman scaling fish. Later she also experimented with Cubist-inspired techniques in works based on African art.

The Harlem Renaissance first directed Jones's attention to Africa and Haiti, especially the bold patterns evident in *Les Fetiches, Paris* (fig. 45). More recently, the civil rights movement of the 1950s and 1960s served to renew that interest, and in recent works Jones has returned to African themes. But her watercolor landscapes and studies for scenes from Europe, Africa, America, and the Caribbean show the breadth of her desire to find fresh sources for her art.

Fig. 36
Augusta Savage
GAMIN. 1930
Collection The Shomburg Center for Research in Black Culture, New York Public Library, New York, New York

Fig. 37
Richmond Barthé
THE NEGRO LOOKS AHEAD. ca. 1940
Collection The Shomburg Center for Research in Black
Culture, New York Public Library, New York, New York

Fig. 38
James L. Wells
JOURNEY TO THE HOLY LAND. n.d.
The Phillips Collection, Washington, D.C.

Fig. 39
Joseph Delaney
PENN STATION AT WAR TIME. 1943
Collection National Museum of American Art, Smithsonian
Institution, Washington, D.C., gift of Joseph Delaney

Fig. 40
Selma Burke
TEMPTATION. 1938
Collection Selma Burke Gallery, Winston-Salem State
University, Winston-Salem, North Carolina

Fig. 41
Marion Perkins
THE KISS. 1948
The Evans-Tibbs Collection, Washington, D.C.

Fig. 42
Lois M. Jones
JENNIE. 1943
Collection Gallery of Art, Howard University,
Washington, D.C.

Fig. 43
James A. Porter
CUBAN BUS. 1943
Collection Gallery of Art, Howard University,
Washington, D.C.

Fig. 44
William H. Johnson
SWING LOW, SWEET CHARIOT. n.d.
Collection National Museum of American Art, Smithsonian
Institution, Washington, D.C., transfer from Museum of
African Art

Fig. 45
Lois M. Jones
LES FETICHES, PARIS. 1938
Lent by the artist, Washington, D.C.

Fig. 46
Beauford Delaney
STREET SCENE. ca. 1940
Courtesy Onyx Gallery, New York, New York

Fig. 47
Norman Lewis
JAZZ MUSICIANS. 1948
Courtesy Luise Ross Gallery, New York, New York

Fig. 48
Romare Bearden
THE BULLFIGHTER. 1947-48
Private Collection

THE AFFIRMATION OF BLACK SUBJECTS

The Black artists who emerged during the late 1930s reaffirmed the commitment to Black themes and subjects of the immediately preceding generation but did not share their interest in Impressionism and Post-Impressionism. Nor did these newer artists accept the American Scene insistence on Realism to exclusion of all other styles; they were becoming far too interested in the internationalist styles that led to the Abstract Expressionist movement of the 1940s and 1950s to limit their scope in that way. In the works of these artists—which included Romare Bearden, Claude Clarke, Eldzier Cortor, Hughie Lee-Smith, Jacob Lawrence, Elizabeth Catlett, Ernest Crichlow, and Charles White—we can see the influence of Cubism, Fauvism, Surrealism, Social Realism, and other art styles from non-western cultures. Referring to this diversity of interests as well as backgrounds, the art historian E. P. Richardson used the expression "a chorus of independent voices giving speech to the imagination in all parts of the country."[82]

For each of these artists the primary aim has been to find a suitable vehicle for depicting the Black experience. With this in mind each has adapted aspects of both Realism and the internationalist styles to create vivid imagery revealing aspects of Black life and culture.

Romare Bearden (b. 1912), one of the most original talents to emerge in the late 1930s, has expressed his view of the role of Black artists in this way: "It would seem that what the young black painter has that is unique is that he has experiences and a way of looking at them that is unique."[83]

Bearden gained notoriety first as a writer, then as an artist.[84] Growing up during the 1920s in the midst of the writers and artists of the Harlem Renaissance, he underwent a broad, rigorous education, attending New York University, the University of Pittsburgh, the Art Students League, Columbia University, and the Sorbonne. In New York he studied with the artist George Grosz.

Over the years Bearden has worked in several different styles—but always from the perspective of the Black artist. Works done as early as 1941, for instance, show the strong influence of African art, although his subjects are often Biblical. Beginning about 1945 and extending into the late 1950s, Bearden began to emphasize the two-dimensionality of the picture plane—as in *The Warriors* (fig. 51) and *The Bullfighter* (fig. 48).[85] In the 1960s he began to work in collage, as he continues to do to the present day. Always, however, a concern for the universal themes of human experience—particularly as they apply to Black life and culture—has been intrinsic to his work.

In the minds of many, Bearden's style has come to be synonymous with modern Black art—or Blackness itself—but in fact his work is richer and more encompassing than that. Two basic themes run through his paintings and collages: order, constancy, pattern, consistency, on the one hand; and newness, discovery, rediscovery, exploration, on the other. For Bearden life is characterized by these two elements; it always follows a familiar, ordered pattern, and yet it is always reaching out to new experiences, new discoveries, and new forms. Both elements are intricately woven into the fabric of his works, in their orderly, geometric structures and their rich, informative, expressive images and shapes. Bearden's work is also autobiographical, filled with his own emotion and joyously expressing his ideas with the rest of the world.

Claude Clarke (b. 1915) has created images of everyday rural and urban life of Blacks, employing a decorative neo-primitive or Fauvist style. The figure study *Resting* (fig. 52) shows his technique of applying layers of paint to the canvas with a palette knife to create a highly tactile surface. He studied at the Philadelphia Museum School, the Barnes Foundation, California State College, and the University of California at Berkeley. Highly stylized, his paintings communicate a painterly joy in texture that is as close to European modernism as it is to the art of the WPA. Like many others, Clark has taken many of his themes from the art of Africa.

The influence of Surrealism is apparent in the disquieting paintings of Eldzier Cortor (b. 1916). Cortor, whose interest in art was stimulated by his association with the Black artist and teacher George Neal, studied at the Art Institute of Chicago, Columbia University, and the Pratt Graphic Art Center. Neal

inspired Cortor to experiment with modernist techniques in paintings that confront the reality of urban Afro-American existence. During the Depression he worked briefly as an easel painter with the WPA.[86] An interest in non-Western art led him to the study of African art, which in turn led him to the South Carolina Sea Islands and their Black inhabitants, the Gullah, who appear to have kept much of their African culture intact.

Many of Cortor's works, especially those from the late 1940s, such as *Room No. V* (fig. 53), depict a brooding, elongated female figure in a stark, decaying room. The sense of futility and isolation in these works is heightened by the surreal manner of their depiction. In these works, Cortor seems to be expressing the nature of Black isolation and a universal sense of loneliness.

Like Cortor, Hughie Lee-Smith (b. 1915) has sought to develop a form of Black expression depicting Black subjects in a style that is neither Academic nor neo-primitive. Also like Cortor, Lee-Smith developed a personal, psychological style that conveys the internal isolation and despair of people living in a hostile urban environment. This style may be seen in *Portrait of a Boy* (fig. 54). Ernest Crichlow (b. 1914), here represented by *Woman in a Blue Coat* (fig. 57), worked in a predominately realist style concentrating on life around him and Black subjects.

While the works of Lee Smith, Cortor, and Bearden look inward, the works of Jacob Lawrence (b. 1917) and Elizabeth Catlett (b. 1910) look outward, engaging in explicit social commentary and attempting to create heroic Black imagery.

Lawrence was a youthful prodigy strongly influenced by the older members of the Harlem Renaissance. He studied at the Harlem Workshop, the Harlem Art Center, and the American Artists School. His 1938 work *Touissant L'Ouverture* was first shown, under Harmon Foundation sponsorship, at the Baltimore Museum of Art in 1939 when Lawrence was only twenty-one; the work was then exhibited at the 1940 Chicago Negro Exhibition, where it was received with great acclaim. A series of paintings portraying the history of the struggle for Haitian independence from France, it was followed by other series with the titles *The Migration*, *John Brown*, *Frederick Douglass*, and *Harriet Tubman*—all stemming from Lawrence's dedication to and interest in the history of the Black people in the New World. His 1940 series *Migration of the Negro* was jointly purchased by The Museum of Modern Art and the Phillips Collection.[87] The untitled work here from the *War Series* (fig. 49) came out of Lawrence's service in the Coast Guard during the War.

Lawrence's style is characterized by simplified directional forms and strong, flat color patterns—as exemplified by *The Party* (cat. no. 76), *Street Scene* (fig. 59), and *The Bus* (cat. no. 78). The works of Orozco, Daumier, Goya, and Breugel, as well as the early modernist Arthur Dove, appear to have been important influences.[88]

Catlett has been equally concerned with creating an art that explicitly addressed social issues affecting Blacks, the Third World, and women. A virtuoso sculptor and printmaker, she received her undergraduate degree from Howard University and her graduate degree in art from the University of Iowa, where she studied with sculptor Ossip Zadkine and the American regionalist painter Grant Wood. She later studied at the Art Institute of Chicago and the Art Students League. Catlett has headed the art department at Dillard University and the sculpture department at the National University in Mexico City, where she resided for more than thirty-five years.[89] She now lives in Cuernavaca.

Catlett's art shows the influences of both African and Mexican sources, the latter at first through her association with Mexican muralists in New York. Her style is characterized by strong, simple forms and forceful symbolism. In works such as *Tired* (cat. no. 82) and *Pensive* (fig. 56), she reduces natural forms to expressive geometric shapes, creating poignant images with unusually readable meanings.

Charles White (1918–1979) was an accomplished painter and graphic artist. Both his paintings and his drawings were characterized by strong contrasts of light and dark and a powerful dynamism stemming from an almost sculptural form. Although a part of the continuing Social Realist tradition, he conveyed his themes and ideas with particular force. His early works contained as much social content as Lawrence's and Catlett's, but his later works turned inward in the manner of Cortor and Bearden. His major

work, completed in 1940, was a mural for the Chicago Public Library entitled *Five Great American Negroes*. In such works, White aimed at uplifting the Black spirit by portraying the Black struggle for survival and idealizing such heroes as Frederick Douglass, Sojourner Truth, and Booker T. Washington. Later works of this sort show didactic tendencies common to WPA art. It was in still later works that White became more introspective, creating images of love and prophecy with great psychological intensity—as in *Lovers #1* (fig. 50) and *Study* (fig. 58).

Many Black artists have arrived at artistic maturity in the years since World War II, but they are beyond the scope of this exhibition, and only one work by these artists has been included—*Portrait of Jackie* (fig. 55) by the sculptor James E. Lewis (b. 1923), who devoted many years to the development of the department of art at Morgan State University in Baltimore.

Fig. 49
Jacob Lawrence
UNTITLED, from the "War Series". 1947
Collection Dr. Meredith Sirmans, New York, New York

Fig. 50
Charles White
LOVERS #1. 1942
Courtesy Heritage Gallery, Los Angeles, California

Fig. 51
Romare Bearden
THE WARRIORS. 1947-48
Private Collection

Fig. 52
Claude Clark
RESTING. 1944
Collection National Museum of American Art, Smithsonian
Institution, Washington, D.C., gift of the Harmon Foundation

Fig. 53
Eldzier Cortor
ROOM NO. V. 1948
Collection Mr. and Mrs. Richard Rosenwald,
Los Angeles, California

Fig. 54
Hughie Lee-Smith
PORTRAIT OF A BOY. 1938
The Evans-Tibbs Collection, Washington, D.C.

Fig. 55
James Lewis
PORTRAIT OF JACKIE. 1949
Collection Professor and Mrs. James E. Lewis,
Baltimore, Maryland

Fig. 56
Elizabeth Catlett
PENSIVE. 1946
Lent by the artist, Cuernavaca, Mexico

Fig. 57
Ernest Crichlow
WOMAN IN A BLUE COAT. ca. 1948
Collection Mr. and Mrs. John H. Hewitt,
New York, New York

Fig. 58
Charles White
STUDY. 1949
Courtesy Heritage Gallery, Los Angeles, California

Fig. 59
Jacob Lawrence
STREET SCENE. 1937
Courtesy Terry Dintenfass Gallery, New York, New York

CONCLUSION

From eighteenth-century artisans through painters like Joshua Johnston, Henry O. Tanner, and Jacob Lawrence to the youngest artists of today, Blacks have worked in every aspect of the visual arts in America—always in the face of great difficulties but often with great success. For many years the record of this important body of work was ignored. In the 1940s, a few pioneering Black historians of art began to uncover it, discovering important artists and recovering irreplacable works that had been all but forgotten.

But much remains to be done. While the achievements of the most celebrated artists have been noted, the relationship between Black art in the United States and the major trends and movements in American and European art have not yet been analyzed in depth. Historians and critics should be particularly sensitive to the impact on Black American artists of African, Carribean, and South American art. Significant, often determining factors like class, education, economics, patronage, and religion need examination.

Only when these and other crucial tasks have been undertaken will we be able to say that the history of Black art in the United States has been removed from its former obscurity and brought into the full light of day. The present exhibition is an occasion to stimulate such work.

NOTES

1. Margaret Just Butcher, *The Negro in American Culture* (New York: Alfred A. Knopf, 1971), 19–39.

2. See James A. Porter, *Modern Negro Art* (New York: Dryden Press, 1943), 24–26, and David C. Driskell, *Two Centuries of Black American Art* (New York: Los Angeles County Museum of Art and Alfred A. Knopf, 1976), 22–28.

3. Porter, *Modern Negro Art*, 14.

4. Porter, *Modern Negro Art*, 30-32.

5. For general reading on this subject, see John Hope Franklin, *From Slavery to Freedom: A History of Negro Americans* (New York: Vintage Press, 1969), and Benjamin Quarles, *The Negro in the American Revolution* (New York: W.W. Norton, 1961).

6. Franklin, *From Slavery to Freedom*, 145, 217.

7. Franklin, *From Slavery to Freedom*, 217–221.

8. See Driskell, *Two Centuries*, 22; see also David C. Driskell, *Amistad II: Afro-American Art* (New York: United Church Board for Homeland Ministries, 1975), 42.

9. See Driskell, *Two Centuries*, 42.

10. See Driskell, *Two Centuries*, 39.

11. Franklin, *From Slavery to Freedom*, 217.

12. See J. Hall Pleasants, "Joshua Johnston, the First Negro Portrait Painter," *Maryland Historical Magazine*, vol. 37, no. 2 (June 1942), 121–49; Lynda R. Hartigan, *Sharing Traditions: Five Black Artists in Nineteenth-Century America* (Washington: Smithsonian Institution, 1985), 39; and Mary Lynn Perry, "Joshua Johnston: His Historical Context and His Art," masters thesis, George Washington University, 1983.

13. See Pleasants, "Joshua Johnston."

14. Hartigan, *Sharing Traditions*, 42. Dr. Hartigan uses the spelling "Johnson," since it appears that way in a signature in an open book in the portrait of Sarah Ogden Gustin (ca. 1805, The National Gallery of Art). But a "Joshua Johnston" was listed in the Baltimore City Directory from 1796 through 1824 (except for 1820) and cited in 1817 as a "Free Householder of Colour." According to information provided by Romare Bearden, a more clearly written signature that is assumed to be the artist's—again with the spelling "Johnston"—appears on the baptismal certificate of Johnston's five children. I have therefore chosen to keep the traditional spelling used by J. Hall Pleasants, the Maryland cultural and art historian who rediscovered Johnston's work in the late 1930s.

15. John Wilmerding, *American Art* (New York: Penguin Books, 1976), 58.

16. Hartigan, *Sharing Traditions*, 51.

17. See Driskell, *Amistad II*, 39.

18. Letter from R. S. Duncanson to Junius R. Sloan, Newberry Library, Chicago. See Hartigan, *Sharing Traditions*, 58–59.

19. See Guy C. McElroy, *Robert S. Duncanson: A Centennial Exhibition* (Cincinnati Art Museum, 1972), 21; and James Dallas Parks, *Robert S. Duncanson: 19th-Century Black Romantic Painter* (Washington: Associated Publishers, 1980), 30.

20. Porter, *Modern Negro Art*, 36.

21. James O. Horton and Lois E. Horton, *Black Bostonians: Family Life and Community Struggle in the Antebellum North* (New York: Holmes and Meiers Publishers, 1979), 9; see also Hartigan, *Sharing Traditions*, 72.

22. The Family of Man Foundation and The Rhode Island Black Heritage Society, *Edward Mitchell Bannister (1828-1901): The World of the Artist* (1981).

23. Lydia Maria Child to Sarah Blake Sturgis Shaw, November 3, 1864, in the Lydia Maria Child Papers, Houghton Library, Harvard University.

24. Hartigan, *Sharing Traditions*, 73.

25. Wilmerding, *American Art*, 145–46.

26. Samella Lewis, *Art: African American* (New York: Harcourt Brace Jovanovich, 1977), 30.

27. John Johns, "Art of Black America," *Sundancer* (October 1976), 80.

28. Hartigan, *Sharing Traditions*, 70.

29. Elsa H. Fine, *The Afro-American Artist: A Search for Identity* (New York: Holt, Rinehart and Winston, 1973), 61–62.

30. Wilmerding, *American Art*, 106–09.

31. Jacqueline F. Bontemps, *Forever Free: Art by African-American Women: 1862–1980* (Alexandria, Virginia: Stephenson, 1980), 98.

32. Eleanor Tufts, *Our Hidden Heritage: Five Centuries of Women Artists* (New York: Paddington Press, 1974), 159.

33. Hartigan, *Sharing Traditions*, 87.

34. Marcia Goldberg, "A Drawing by Edmonia Lewis," *The American Art Journal* (November 1977), 104.

35. Leonard Simon, "Edmonia Lewis: An Artist of Her Times," unpublished manuscript, February, 1981.

36. Porter, *Modern Negro Art*, 62–63.

37. Lorado Taft, *History of American Sculpture* (New York: Macmillan, 1924), 61–62.

38. Phillip M. Montesano, "The Mystery of the San Jose Statues," *Urban West*, vol. 1, no. 4 (March-April 1968), 27.

39. Hartigan, *Sharing Traditions*, 107.

40. This work has sometimes been called *Christ Learning to Read*.

41. Leonard Simon, "The American Presence of the Black Artist," *American Art Review* (November-December, 1976), 112–13.

42. Porter, *Modern Negro Art*, 7; Lewis, *Art: African American*, 53.

43. Bontemps, *Forever Free*, 22.

44. Author's translation of the titles.

45. Guy C. McElroy, "Afro-American Women Pioneers in the Visual Arts," unpublished manuscript, 5.

46. During the First World War and for a time after, many Black Americans used the term "Ethiopian" (which is derived from a Greek word meaning "person with burnt face") in the same way they used "Black" or "Negro."

47. Peter d'Arbanville Jones, *The U.S.A.: A History of Its People and Society from 1865* (Georgetown, Ontario: Irwin Dorsey, 1976), 563.

48. McElroy, "Afro-American," 7.

49. David Levering Lewis, *When Harlem Was in Vogue* (New York: Vintage Books, 1982), 28–29.

50. Franklin, *From Slavery to Freedom*, 39.

51. Lewis, *When Harlem Was in Vogue*, 121.

52. Porter, *Modern Negro Art*, 84.

53. Porter, *Modern Negro Art*, 93.

54. E. P. Richardson, *A Short History of American Painting* (New York: Harper and Row, 1963), 210.

55. Porter, *Modern Negro Art*, 106.

56. See Driskell, *Two Centuries*, 58.

57. Alain L. Locke, *Negro Art, Past and Present* (Washington: Associates in Negro Folk Education, 1936), 7.

58. Lewis, *Art: African American*, 73.

59. Lewis, *Art: African American*, 71.

60. Lewis, *Art: African American*, 75.

61. Porter, *Modern Negro Art*, 122.

62. Fine, *The Afro-American Artist*, 116.

63. Richardson, *A Short History*, 256.

64. Locke, *Negro Art*, 47.

65. Porter, *Modern Negro Art*, 100-08.

66. Porter, *Modern Negro Art*, 129.

67. McElroy, "Afro-American," 9.

68. Lewis, *Art: African American*, 84.

69. Fine, *The Afro-American Artist*, 153–55.

70. Lewis, *Art: African American*, 68.

71. Barbara Rose, *American Art Since 1900: A Critical History* (New York: Praeger, 1967), 126–27.

72. Porter, *Modern Negro Art*, 123.

73. See Driskell, *Two Centuries*, 163.

74. *Exhibit of Fine Arts by American Negro Artists* (New York: Harmon Foundation, 1930), 15.

75. Lewis, *Art: African American*, 88–89.

76. Adelyn D. Breeskin, *William H. Johnson, 1901–1970* (Washington: National Collection of Fine Arts, Smithsonian Institution, 1970), 14.

77. Porter, *Modern Negro Art*, 124.

78. Lewis, *Art: African American*, 92.

79. "Selma Burke Speaks," an oral presentation at the Harlem Renaissance Conference, Hofstra University, Hempstead, New York, May 3, 1985.

80. Keith Morrison, *Art in Washington and Its Afro-American Presence: 1940-1970* (Washington: Washington Project for the Arts, 1985), 13.

81. See Driskell, *Two Centuries*, 163.

82. Richardson, *A Short History*, 297.

83. Elton Fax, *Seventeen Black Artists*, (New York: Dodd, Meade, 1971), 145.

84. See Romare Bearden, "The Negro Artist's Dilemma," *Critique: A Review of Contemporary Art*, vol. 1, no. 2 (November 1946), 20.

85. Lewis, *Art: African American*, 114.

86. Lewis, *Art: African American*, 115.

87. Lewis, *Art: African American*, 118.

88. See Driskell, *Two Centuries*, 69.

89. Lewis, *Art: African American*, 123.

EXHIBITION CHECKLIST

JOSHUA JOHNSTON (1765-1830)

1. MOTHER AND DAUGHTER. 1805
 Oil on canvas
 30½ x 24¾ in.
 Collection Dr. and Mrs. William H. Cosby, Jr., Greenfield, Massachusetts

2. EDWARD AND SARAH RUTTER. ca. 1805
 Oil on canvas
 36 x 32 in.
 Collection The Metropolitan Museum of Art, New York, New York, gift of Edgar William and Bernice Chrysler Garbisch, 1965
 (Exhibited in Toledo, Baltimore, Philadelphia, and Oklahoma City only)

3. PORTRAIT OF ISABELLA TAYLOR. ca. 1805
 Oil on canvas
 30 x 24⅞ in.
 Collection The Newark Museum, Newark, New Jersey
 (Exhibited in Bellevue, Bronx, Los Angeles, Hartford, Charlotte, and San Antonio only)

4. GENTLEMAN OF THE SHURE FAMILY. ca. 1810
 Oil on canvas
 28⅛ x 22¹³⁄₁₆ in.
 Collection The Baltimore Museum of Art, gift of Edgar William and Bernice Chrysler Garbisch, 1972
 (Exhibited in Toledo, Baltimore, Philadelphia, and Oklahoma City only)

5. BALTIMORE SHIPOWNER. ca. 1815
 Oil on canvas
 19¼ x 15¼ in.
 Barbara Johnson Collection, Princeton, New Jersey

6. BALTIMORE SHIPOWNER'S WIFE. ca. 1815
 Oil on canvas
 19¼ x 15¼ in.
 Barbara Johnson Collection, Princeton, New Jersey

WILLIAM SIMPSON (1818-1872)

7. PORTRAIT OF CHARITY BANKS. ca. 1870
 Oil on canvas
 25½ x 21½ in.
 Collection Maryland Commission of Afro-American History and Culture (on extended loan from the History Department of the University of Maryland), Annapolis, Maryland

DAVID BOWSER (1820-1900)

8. THE BALD EAGLE AND THE SHIELD OF THE UNITED STATES. 1847
 Oil on canvas
 15½ x 19⅞ in.
 Collection Atwater Kent Museum, The History Museum of Philadelphia, Pennsylvania

ROBERT S. DUNCANSON (1821/22-1872)

9. THE CATCH. 1848
 Oil on canvas
 18 x 24 in.
 Private Collection

10. MAN FISHING. 1848
 Oil on canvas
 25 x 30 in.
 Private Collection

11. FRUIT STILL LIFE. 1849
 Oil on canvas
 13½ x 19 in.
 Collection Corcoran Gallery of Art, Washington, D.C., Museum Purchase, 1968

12. LANDSCAPE WITH CLASSICAL RUINS. 1854
 Oil on canvas
 34 x 49½ in.
 Collection Gallery of Art, Howard University, Washington, D.C.

13. ITALIANATE LANDSCAPE. 1855
 Oil on canvas
 26 x 36 in.
 Collection California Afro-American Museum, Los Angeles, California

EDWARD M. BANNISTER (1828-1901)

14. OAK TREES. 1870
 Oil in canvas
 34⅛ x 60⅝ in.
 Collection National Museum of American Art, Smithsonian Institution, Washington, D.C., transfer from Museum of African Art

15. PROVIDENCE HARBOR. 1881
 Oil on canvas
 14¼ x 20¼ in.
 Collection Mr. and Mrs. David E. Leven, Providence, Rhode Island

16. PALMER RIVER. 1885
 Oil on canvas
 24 x 34 in.
 Collection Mr. and Mrs. Daniel Mechnig, Providence, Rhode Island

17. LANDSCAPE FIGURES AND COWS. 1890
 Oil on canvas
 24 x 36 in.
 Collection Francine and Marilyn Aron, Cranston, Rhode Island

GRAFTON T. BROWN (1841-1918)

18. LONG LAKE. 1883
 Oil on canvas
 16⅛ x 26 in.
 Collection Provincial Archives of British Columbia, Victoria, British Columbia

19. ABOVE THE GORGE. 1883
 Oil on canvas
 16⅛ x 26 in.
 Collection Provincial Archives of British Columbia, Victoria, British Columbia

MARY EDMONIA LEWIS (1843/45-ca. 1912)

20. FOREVER FREE. 1867
 Marble
 41¼ x 11 x 17 in.
 Collection Gallery of Art, Howard University, Washington, D.C.

21. ASLEEP. 1871
 Marble
 24½ x 24 x 16 in.
 Collection San Jose Public Library, San Jose, California

22. AWAKE. 1872
 Marble
 23 x 19½ x 13¼ in.
 Collection San Jose Public Library, San Jose, California

23. THE ARROWMAKER AND DAUGHTER. ca. 1872
 Marble
 24 x 13 in.
 Collection Tuskegee Institute, Tuskegee, Alabama

HENRY O. TANNER (1859-1937)

24. THE BAGPIPE LESSON. 1893
 Oil on canvas
 43 x 68¾ in.
 Collection Hampton University Museum, Hampton, Virginia
 (Exhibited in Hartford, Charlotte, San Antonio, Toledo, Baltimore, Philadelphia, and Oklahoma City only)

25. THE THANKFUL POOR. 1894
 Oil on canvas
 35½ x 44¼ in.
 Collection Dr. and Mrs. William H. Cosby, Jr., Greenfield, Massachusetts
 (Exhibited in Hartford, Charlotte, San Antonio, Toledo, Baltimore, and Philadelphia only)

26. THE DISCIPLES ON THE SEA. ca. 1910
 Oil on canvas
 21⅝ x 26½ in.
 Collection The Toledo Museum of Art, Toledo, Ohio, gift of Frank W. Gunsaulus

27. CHRIST WALKING ON THE WATER. ca. 1911
 Oil on canvas
 51½ x 42 in.
 Collection Des Moines Art Center, Des Moines, Iowa, gift of the Des Moines Association of Fine Arts

28. DESTRUCTION OF SODOM AND GOMORRAH. n.d.
 Oil on canvas
 36 x 48½ in.
 Collection Mr. and Mrs. Haig Tashjian, New York, New York

29. CHRIST AND HIS MOTHER STUDYING THE SCRIPTURES. n.d.
 Oil on canvas
 48½ x 40 in.
 Collection Dallas Museum of Art, Deaccession Funds/City of Dallas

WILLIAM A. HARPER (1873-1910)

30. LANDSCAPE WITH POPLARS (AFTERNOON AT MONTIGNY). ca. 1898
 Oil on canvas
 23 x 28 in.
 Collection Gallery of Art, Howard University, Washington, D.C.

WILLIAM E. SCOTT (1884-1964)

31. HAITIAN MARKET. 1950
 Oil on canvas
 28 x 46½ in.
 Collection Fisk University Museum, Nashville

SARGENT JOHNSON (1887-1967)

32. MASK: YOUNG GIRL WITH GOLDEN BRAIDS. n.d.
 Copper
 9 x 6 x 2½ in.
 Collection Marc-Primus Davy, New York, New York

33. WOMAN'S HEAD. n.d.
 Stone
 14½ x 7½ x 10⅛ in.
 Collection San Francisco Museum of Modern Art, San Francisco, California, Albert M. Bender Collection, bequest of Albert M. Bender

HORACE PIPPIN (1888-1946)

34. JOHN BROWN GOING TO HIS HANGING, from the "John Brown" series. 1942
 Oil on canvas
 24 x 30 in.
 Collection Pennsylvania Academy of the Fine Arts, Philadelphia, Pennsylvania, Lambert Fund Purchase, 1943

35. SAYING PRAYERS. 1943
 Oil on canvas
 16 x 20⅛ in.
 Collection Brandywine River Museum, Chadds Ford, Pennsylvania, The Betsy James Wyeth Fund
 (Exhibited in Toledo, Baltimore, Philadelphia, and Oklahoma City only.)

36. HARMONIZING. 1944
 Oil on canvas
 24 x 30 in.
 Collection Allen Memorial Art Museum, Oberlin College, Oberlin, Ohio, gift of Mr. and Mrs. Joseph Bissett
 (Exhibited in Bronx, Los Angeles, Hartford, Charlotte, and San Antonio only)

37. BARRACKS. 1945
 Oil on canvas
 25¼ x 30 in.
 The Phillips Collection, Washington, D.C.

ELIZABETH PROPHET (1890-1960)

38. SILENCE. n.d.
 Marble
 12 x 8 x 8¾ in.
 Collection Museum of Art, Rhode Island School of Design, Providence, Rhode Island, gift of Miss Ellen D. Sharpe

ARCHIBALD MOTLEY, JR. (1891-1980)

39. MENDING SOCKS. 1924
 Oil on canvas
 43⅞ x 40 in.
 Collection North Carolina Museum of Art, Raleigh, North Carolina
 (Exhibited in Bellevue, Bronx, Los Angeles, Hartford, and Charlotte only)

40. BLACK BELT. 1934
 Oil on canvas
 31⅞ x 39¼ in.
 Collection Hampton University Museum, Hampton, Virginia

41. JAZZ SINGERS. n.d.
 Oil on canvas
 32 x 42½ in.
 Collection Western Illinois University Art Gallery/Museum, Macomb, Illinois

AUGUSTA SAVAGE (1892-1962)

42. GAMIN. 1930
 Bronze
 16½ x 9¼ x 8¼ in.
 Collection The Shomburg Center for Research in Black Culture, New York Public Library, New York, New York

PALMER HAYDEN (1893-1973)

43. MIDSUMMER NIGHT IN HARLEM. 1938
Oil on canvas
25 x 30 in.
Collection Museum of African American Art, Los Angeles, California, Palmer C. Hayden Collection, gift of Miriam A. Hayden
(Exhibited in Bellevue, Bronx, Los Angeles, Hartford, and Charlotte only)

44. WHEN TRICKY SAM SHOT FATHER LAMB. 1940
Oil on canvas
30½ x 39⅞ in.
Collection Ozier Muhammad and Carol Penn-Muhammad, Jamaica, New York
(Exhibited in San Antonio, Toledo, Baltimore, Philadelphia, and Oklahoma City only)

45. BIG BEND TUNNEL, from the "Ballad of John Henry" series. 1944-54
Oil on canvas
30 x40 in.
Collection Museum of African American Art, Los Angeles, California, Palmer C. Hayden Collection, gift of Miriam A. Hayden

MALVIN G. JOHNSON (1896-1934)

46. ELKS MARCHING. 1931
Oil on canvas
22 x 25 in.
Aaron Douglas Collection, Amistad Research Center, New Orleans, Louisiana

AARON DOUGLAS (1899-1979)

47. NOAH'S ARK. ca. 1927
Oil on Masonite
48 x 36 in.
Collection Fisk University Museum of Art, Nashville, Tennessee

48. STUDY FOR ASPECTS OF NEGRO LIFE (FROM SLAVERY THROUGH RECONSTRUCTION). 1934
Tempera on paper
11 x 26 in.
Collection Stephanie E. Pogue, Hyattsville, Maryland

49. STUDY FOR ASPECTS OF NEGRO LIFE (IDYLL OF THE DEEP SOUTH). 1934
Tempera on paper
11 x 26 in.
Collection Professor and Mrs. David C. Driskell, Hyattsville, Maryland

50. GO DOWN DEATH. 1927
Oil on masonite
48 x 36 in.
Collection Professor and Mrs. David C. Driskell, Hyattsville, Maryland

META VAUX WARRICK FULLER (1877-1968)

51. ETHIOPIA AWAKENING. n.d.
Cast stone and plaster, painted
13¼ x 3¼ x 3½ in.
Collection Meta Warrick Fuller Legacy, Inc., Framingham, Massachusetts

52. WATERBOY #1. 1930
Bronze
13½ x 4½ x 4½ in.
Collection Meta Warrick Fuller Legacy, Inc., Framingham, Massachusetts

ELLIS WILSON (1899-1977)

53. SHORE LEAVE. n.d.
Oil on Masonite
16¼ x 20¼ in.
Aaron Douglas Collection, Amistad Research Center, New Orleans, Louisiana

HALE WOODRUFF (1900-1980)

54. THE CARD PLAYERS. 1930
Oil on Canvas
22 x 28 in.
Collection Mr. and Mrs. John H. Hewitt, New York, New York

RICHMOND BARTHÉ (b. 1901)

55. THE NEGRO LOOKS AHEAD. ca. 1940
Bronze
16 x 10½ x 10½ in.
Collection The Shomburg Center for Research in Black Culture, New York Public Library, New York, New York

56. BIRTH OF THE SPIRITUALS (SINGING SLAVE). ca. 1940
Bronze
11¾ x 11½ x 5½ in.
Collection The Shomburg Center for Research in Black Culture, New York Public Library, New York, New York

SELMA BURKE (b. 1901)

57. TEMPTATION. 1938
Limestone
15 x 10 in.
Collection Selma Burke Gallery, Winston-Salem State University, Winston-Salem, North Carolina

BEAUFORD DELANEY (1901-1980)

58. STREET SCENE. ca. 1940
Oil on board
18 x 21 in.
Courtesy Onyx Gallery, New York, New York

WILLIAM H. JOHNSON (1901-1970)

59. JESUS AND THREE MARYS. 1939
Oil on board
34¼ x 37 in.
Collection Gallery of Art, Howard University, Washington, D.C.

60. SWING LOW, SWEET CHARIOT. n.d.
Oil on cardboard
28½ x 26½ in.
Collection National Museum of American Art, Smithsonian Institution, Washington, D.C., transfer from Museum of African Art

JAMES L. WELLS (b. 1902)

61. JOURNEY TO THE HOLY LAND. n.d.
Oil on canvas board
14½ x 19¾ in.
The Phillips Collection, Washington, D.C.

JOSEPH DELANEY (b. 1904)

62. PENN STATION AT WAR TIME. 1943
Oil on canvas
34 x 48⅛ in.
Collection National Museum of American Art, Smithsonian Institution, Washington, D.C., gift of Joseph Delaney

LOIS M. JONES (b. 1905)

63. LES FETICHES, PARIS. 1938
 Oil on canvas
 25½ x 21 in.
 Lent by the artist, Washington, D.C.

64. JENNIE. 1943
 Oil on canvas
 28¾ x 36¼ in.
 Collection Gallery of Art, Howard University, Washington, D.C.

JAMES A. PORTER (1905-1970)

65. CUBAN BUS. 1943
 Oil on canvas
 32 x 24 in.
 Collection Gallery of Art, Howard University, Washington, D.C.

CHARLES ALSTON (1907-1977)

66. FARM BOY. 1941
 Gouache on paper
 25¼ x 20 in.
 Collection The Atlanta University Collection of Afro-American Art, Atlanta, Georgia

MARION PERKINS (1908-1961)

67. THE KISS. 1948
 Granite
 11 x 20 x 2 in.
 The Evans-Tibbs Collection, Washington, D.C.

NORMAN LEWIS (1909-1981)

68. JAZZ MUSICIANS. 1948
 Oil on canvas
 50 x 42 in.
 Courtesy Luise Ross Gallery, New York, New York

ROMARE BEARDEN (b. 1914)

69. THE WARRIORS. 1947-48
 Watercolor
 32¾ x 26¾ in.
 Private Collection

70. THE BULLFIGHTER. 1947-48
 Watercolor
 24¼ x 30¼ in.
 Private Collection

ERNEST CRICHLOW (b. 1914)

71. WOMAN IN A BLUE COAT. ca. 1948
 Oil on canvas
 20 x 16 in.
 Collection Mr. and Mrs. John H. Hewitt, New York, New York

CHARLES SEBREE (1914-1985)

72. THE BLUE JACKET. 1938
 Oil on canvas
 30 x 24 in.
 The Evans-Tibbs Collection, Washington, D.C.

HUGHIE LEE-SMITH (b. 1915)

73. PORTRAIT OF A BOY. 1938
 Oil on canvas
 24 x 18 in.
 The Evans-Tibbs Collection, Washington, D.C.

CLAUDE CLARK (b. 1915)

74. RESTING. 1944
 Oil on canvas
 30 x 25 in.
 Collection National Museum of American Art, Smithsonian Institution, Washington, D.C., gift of the Harmon Foundation

ELDZIER CORTOR (b. 1916)

75. ROOM NO. V. 1948
 Oil on board
 37 x 27 in.
 Collection Mr. and Mrs. Richard Rosenwald, Los Angeles, California

JACOB LAWRENCE (b. 1917)

76. THE PARTY. 1935
 Gouache on paper
 17½ x 22½ in.
 Courtesy Terry Dintenfass Gallery, New York, New York

77. STREET SCENE. 1937
 Gouache on paper
 8¾ x 12¾ in.
 Courtesy Terry Dintenfass Gallery, New York, New York

78. THE BUS. 1941
 Gouache on paper
 17 x 22 in.
 Collection of George and Joyce Wein

79. UNTITLED, from the "War Series". 1947
 Gouache on paper
 15½ x 19¾ in.
 Collection Dr. Meredith Sirmans, New York, New York

CHARLES WHITE (1918-1979)

80. LOVERS #1. 1942
 Egg tempera on board
 19¾ x 26 in.
 Courtesy Heritage Gallery, Los Angeles, California

81. STUDY. 1949
 Mixed media: charcoal, ink, conte on board
 43 x 47 in.
 Courtesy Heritage Gallery, Los Angeles, California

ELIZABETH CATLETT (b. 1919)

82. TIRED. 1946
 Terra cotta
 H: 13½ in.
 Collection Gallery of Art, Howard University, Washington, D.C.

83. PENSIVE. 1946
 Bronze
 16½ x 10½ x 7⅞ in.
 Lent by the artist, Cuernavaca, Mexico

JAMES LEWIS (b. 1923)

84. PORTRAIT OF JACKIE. 1949
 Bronze
 15 x 15 x 10 in.
 Collection Professor and Mrs. James E. Lewis, Baltimore, Maryland

BIBLIOGRAPHY

BOOKS

Alabama: A Guide to the Deep South. Compiled by Workers of the Writers Program of the Work Projects Administration in the State of Alabama. New York: Richard R. Smith, 1941.

Allen, James D. *The Negro Question in the United States.* New York: International Publishers, 1936.

Allen, Richard. *The Life, Experience and Gospel Labours of the Rt. Rev. Richard Allen, to Which is Annexed the Rise and Progress of the African Methodist Episcopal Church in the United States of America. Written by Himself and Published by His Request.* Philadelphia: F. Ford and M. A. Riply, 1880.

Andrews, Charles C. *The History of the New York African Free Schools. From their Establishment in 1787 to the Present Time.* New York: M. Day, 1830.

The Annual Report of the American and Foreign Anti-Slavery Society, Presented at New York, May 7, 1850: With the Addresses and Resolutions. New York: American and Foreign Anti-Slavery Society, 1850.

Aptheker, Herbert, ed. *A Documentary History of the Negro People in the United States.* 3 Vols. New York: Citadel Press, 1974.

Arnold, John N. *Art and Artists of Rhode Island.* Providence: Rhode Island Citizens Association, 1905.

Atkinson, J. Edward, and Driskell, David C. *Black Dimensions in Contemporary American Art.* New York: New American Library, 1971.

Barbadoes, F. G., ed. *Catalogue of the First Industrial Exposition by the Colored Citizens of the District of Columbia.* Washington, D.C.: R. O. Polkinhorn, 1887.

Barnes, Gilbert H., and Dumond, Dwight L. *Letters of Theodore Dwight Weld, Angelina Grimke Weld and Sarah Grimke, 1822–1844.* New York: Appleton-Century, 1934.

Barr, Alfred. *Cubism and Abstract Art.* New York: Museum of Modern Art, 1936.

Bearden, Romare, and Henderson, Harry. *Six Black Masters of American Art.* New York: Zenith Books, Doubleday, 1972.

Bennett, Charles A. *History of Manual and Industrial Education up to 1870.* Peoria, Illinois: The Manual Arts Press, 1927.

Bermingham, Peter. *American Art in the Barbizon Mood.* Washington, D.C.: Smithsonian Institution Press, 1975.

Bird, M. B. *The Blackman; or, Haytian Independence.* New York: Published by the Author, 1869.

Black American Artists of Yesterday and Today. Black Heritage Series. Dayton: George A. Pflaum, 1909.

Bontemps, Jacqueline F. *Forever Free: Art by African-American Women, 1862–1980.* Alexandria, Virginia: Stephenson, 1980.

Boswell, Peyton, Jr. *Modern American Painting.* New York: Dodd, Mead, 1939.

Brawley, Benjamin G. *The Negro Genius.* New York: Dodd, Mead, 1937.

———. *The Negro in Literature and Art in the United States.* New York: Dodd, Mead, 1934.

Brown, Sterling. *The Negro Caravan.* New York: Dryden Press, 1942.

Brown, Sterling. *The Negro in American Fiction and Negro Poetry and Drama.* Washington, D.C.: The Associates in Negro Folk Education, 1937.

Brown, William Wells. *The Blackman.* New York: Thomas Hamilton, 1864.

———. *The Rising Sun; or, the Antecedents and Advancement of the Colored Race.* Boston: A. G. Brown and Co., 1876.

Burton, E. Milby. *South Carolina Silversmiths, 1690–1800.* Charleston: Charleston Museum, 1942.

Butcher, Margaret Just. *The Negro in American Culture.* New York: Knopf, 1971.

Cahill, Holger, and Barr, Alfred, Jr., eds. *Art in America in Modern Times.* New York: Reynal and Hitchcock, 1934.

Cahill, Holger, Gauthier, Maximilien, and others. *Masters of Popular Paintings; Modern Primitives of Europe and America.* New York: The Museum of Modern Art, 1938.

Castellanos, Henry C. *New Orleans as It Was. Episodes of Louisiana Life.* New Orleans: Graham, 1895.

Chase, Judith W. *Afro-American Art and Craft.* New York: Van Nostrand Reinhold, 1971.

Child, Lydia Maria. *The Fountain for Every Day in the Year.* New York: R. C. Williams, for the American Anti-Slavery Society, 1836.

———. *The Fountain for Every Day in the Year.* New York: John S. Taylor, 1846.

Clark, Victor S. *History of Manufacturers in the United States.* New York: McGraw-Hill, 1929.

Clement, C.E., and Hutton, Laurence. *Artists of the Nineteenth Century and Their Work.* Boston and New York: Houghton Mifflin, 1907.

Craven, Thomas, ed. *A Treasury of American Prints.* New York: Simon and Schuster, 1939.

Dabney, Wendell P. *Cincinnati's Colored Citizens.* Cincinnati: Dabney Publishing Co., 1926.

Daniels, John. *In Freedom's Birthplace, a Study of Boston Negroes.* Boston: Houghton Mifflin, 1914.

Davidson, Basil. *The African Past.* New York: Grosset & Dunlap, 1967.

Davison, Ruth M., and Legler, April, comps. *Government Publications on the American Negro in America, 1948–1968.* Bloomington, Ind.: Indiana University Press, 1969.

Delaney, Martin R. *The Condition, Elevation, Emigration and Destiny of the Colored People of the United States, Politically Considered.* Philadelphia: Published by the Author, 1852.

Desdunes, Rudolph. *Nos Hommes et Notre Histoire. Notices Biographiques Accompagnées de Réflexions et de Souveniers Personnels.* Montreal: Arbour Dupont, 1911.

Dover, Cedric. *American Negro Art.* Greenwich, Connecticut: New York Graphic Society, 1969.

Dow, George, F. *The Arts and Crafts in New England, 1704-1775.* Topsfield, Massachusetts: Wayside Press, 1927.

Driskell, David C. *Amistad II: Afro-American Art.* New York: United Church Board for Homeland Ministries, 1975.

———. *Soul Motion.* Nashville: Division of Cultural Research, Fisk University, 1973.

———. *Two Centuries of Black American Art.* New York: Los Angeles County Museum of Art and Knopf, 1976.

Du Bois, W. E. B. *The Gift of Black Folk.* Boston: Stratford Publishers, 1924.

_____. *The Negro Artisan.* Atlanta: Atlanta University Press, 1927.

_____. *The Philadelphia Negro; A Social Study.* Philadelphia: University of Pennsylvania, 1899.

_____. *The Souls of Black Folk: Essays and Sketches.* Boston: Stratford Publishers, 1924. Reprint: Boston: Fawcett Publications, 1961.

Dunbar, Ernest, ed. *The Black Expatriates.* New York: E. P. Dutton and Co., 1968.

Dunlap, William. *History of the Rise and Progress of the Arts of Design in the United States.* Boston: C. E. Goodspeed, 1918.

Earle, Alice M. *Home Life in Colonial Days.* New York: Macmillan, 1899.

Fielding, Mantle. *Dictionary of American Painters, Sculptors and Engravers.* Philadelphia: Printed for the Subscribers, 1926.

Fine, Elsa H. *The Afro-American Artist: A Search for Identity.* New York: Holt, Rinehart and Winston, 1973.

Frankhauer, Mary E. *Biographical Sketches of American Artists.* Lansing: Michigan State Library, 1924.

Franklin, John Hope. *From Slavery to Freedom: A History of Negro Americans.* New York: Vintage Books, 1969.

Frazier, E. Franklin. *The Free Negro Family: A Study of Family Origins Before the Civil War.* Nashville: Fisk University, 1932.

_____. *Black Bourgeoisie: The Rise of a Black Middle Class.* New York: Macmillan, 1962.

French, H. W. *Art and Artists in Connecticut.* Boston: Lee and Shephard, 1879.

Friends of Freedom. *The Liberty Bell by the Friends of Freedom.* Boston: For the Massachusetts Anti-Slavery Fair, 1837.

Fry, Roger. *Vision and Design.* London: Chatto and Windus, 1920.

Fuller, Edmund L. *Visions in Stone: The Sculpture of William Edmondson.* Pittsburgh: University of Pittsburgh, 1973.

Gardi, Rene. *Indigenous African Architecture.* New York: Van Nostrand Reinhold, 1973.

Garrison, William L. *William Lloyd Garrison, 1805–1879. The Story of His Life as Told by His Children.* Vol. 2. New York: Century, 1885.

Geerlings, Gerald K. *Wrought Iron in Architecture.* New York: Scribner's, 1929.

Goldwater, Robert J. *Primitivism in Modern Painting.* New York: Harper, 1938.

Greene, Lorenzo Johnson. *The Negro in Colonial New England, 1620–1776.* New York: Columbia University Press, 1942.

Haley, James T. *Afro-American Encyclopedia: Or, the Thoughts, Doings and Sayings of the Race.* Nashville: Haley and Florida, 1896.

Handy, James A. *Scraps of African Methodist Episcopal History.* Philadelphia: A.M.E. Book Concern, n.d.

Hartigan, Lynda R. *Sharing Traditions: Five Black Artists in Nineteenth-Century America.* Washington, D.C.: Smithsonian Institution Press, 1985.

Harvard University Library. *Resources of the Harvard University Library for Afro-American and African Studies.* Cambridge: Harvard University Press, 1969.

Herskovits, Melville J. *Acculturation: The Study of Culture Contact.* New York: T.S. Augustus, 1938.

_____. *The Myth of the Negro Past.* New York: Harper, 1941.

Historical Sketch Book and Guide to New Orleans and Environs. Edited and compiled by several leading writers of the New Orleans Press. New York: Will H. Coleman, 1885.

Horowitz, Benjamin. *Images of Dignity (The Drawings of Charles White).* Glendale, California: Ward Ritchie Press, 1967.

Ruggins, Nathan. *The Harlem Renaissance.* New York: Oxford University Press, 1971.

Hughes, Langston. *A Pictorial History of the Negro in America.* New York: Crown, 1956.

Igoe, Lynn M. *Two-Hundred-and-Fifty Years of Afro-American Art: An Annotated Bibliography.* New York: R. R. Bowker, 1981.

Isaacs, Edith J. R. *The Negro in the American Theatre.* New York: Theatre Arts, 1947.

Jackson, Giles B., and Davis, D. Webster. *The Industrial History of the Negro Race of the United States.* Richmond: The Virginia Press, 1908.

Janis, Sidney. *They Taught Themselves: American Primitive Painters of the Twentieth Century.* Port Washington, New York: Kennikat Press, 1942.

Jernegan, Marcus W. *Laboring and Dependent Classes in Colonial America, 1607–1783.* Chicago: University of Chicago Press, 1931.

Johnson, Charles S. *The Economic Status of the Negro.* Nashville: Fisk University Press, 1933.

Johnson, James Weldon. *Black Manhattan.* New York: Knopf, 1930.

_____. *The Book of American Negro Poetry.* Revised edition, New York: Harcourt Brace, 1931.

_____. *God's Trombones: Seven Negro Sermons in Verse.* New York: Viking Press, 1927.

Johnston, Frances B., and Waterman, T. *The Early Architecture of North Carolina.* Chapel Hill: University of North Carolina Press, 1941.

Jones, Peter d'Arbanville. *The U.S.A.: A History of Its People and Society from 1865.* Georgetown, Ontario: Irwin Dorsey Ltd., 1976.

Kendall, Johns. *History of New Orleans.* New York: William Lewis, 1922.

Keppel, Frederick P., and Duffus, R. L. *The Arts in American Life.* New York: McGraw-Hill, 1933.

King, Grace. *History of Louisiana.* New York: F. F. Hansell & Brothers, 1903.

Kletzing, Henry F. *Progress of a Race.* Atlanta: J. L. Nichols and Co., 1897.

Langston, John M. *From the Virginia Plantation to the National Capitol.* Hartford, Connecticut: American Publishing Co., 1894.

Larkin, Oliver. *Art and Life in America.* New York: Holt, Rinehart and Winston, 1960.

Levine, Lawrence. *Black Culture, Black Consciousness.* New York: Oxford University Press, 1977.

Lewis, David Levering. *When Harlem Was in Vogue.* New York: Knopf, 1981. Reprint: New York: Vintage Books, 1982.

Lewis, Samella. *Art: African American.* New York: Harcourt, Brace, Jovanovich, 1978.

_____. *The Art of Elizabeth Catlett.* Claremont, California: Hancraft Studios, 1984.

Locke, Alain L. *Negro Art: Past and Present.* Washington, D.C.: Associates in Negro Folk Education, 1936.

_____. *The Negro in Art. A Pictorial Record of the Negro Artist and of the Negro Theme in Art.* Washington, D.C.: Associates in Negro Folk Education, 1940. Reprint: New York: Hacker Art Books, 1968.

_____, ed. *The New Negro: An Interpretation.* New York: Albert and Charles Boni, 1925. Reprint: Boston: Atheneum Press, 1968.

Logan, Rayford W., ed. *What the Negro Wants.* Chapel Hill: University of North Carolina Press, 1944.

_____, et al. *The New Negro Thirty Years Afterward (a Memorial to Alain Locke).* Washington, D.C.: Howard University Press, 1955.

Long, John Dixon. *Pictures of Slavery in Church and State; Including Personal Reminiscences, Biographical Sketches, Anecdotes.* Philadelphia: Published by the Author, 1857.

Louisiana: A Guide to the State. Compiled by Workers of the Writers Program of the Work Projects Administration in the State of Louisiana. New York: Hastings House, 1941.

Lynes, Russell. *The Art Makers: An Informal History of Painting, Sculpture and Architecture in Nineteenth Century America.* New York: Dover Publications, 1982.

Majors, Monroe A. *Noted Negro Women, Their Triumphs and Activities.* Chicago: Donohue and Henneberry, 1893.

Mallett, Daniel Trowbridge. *Mallett's Index of Artists: International-Biographical: Including Painters, Sculptors, Illustrators, Engravers, and Etchers of the Past and Present. Orig. and Supplement.* New York: Peter Smith, 1948.

Massachusetts Artists Centennial Album. Boston: J. A. Osgood and Co., 1875.

McKay, Claude. *Home to Harlem.* New York: Harper, 1928.

_____. *Harlem: Negro Metropolis.* New York: Dutton, 1940.

McElroy, Guy C. *Robert S. Duncanson, A Centennial Exhibition.* Cincinnati: Cincinnati Art Museum, 1972.

Miller, Elizabeth W. *Negro in America: A Bibliography.* Cambridge: Harvard University Press, for the American Academy of Arts and Sciences, 1966.

Minton, Henry M. *Early History of the Negroes in Business in Philadelphia.* Nashville: A.M.E. Sunday School Union, 1828.

Morrison, Keith. *Art in Washington and Its Afro-American Presence: 1940–1970.* Washington, D.C.: Washington Project for the Arts, 1985.

Morsbach, Mabel. *The Negro in American Life.* New York: Harcourt Brace and World, in conjunction with the Cincinnati Public Schools, 1967.

Mossell, Nathan F. *The Work of the Afro-American Woman.* Philadelphia: George S. Ferguson, 1908.

Murray, Freeman. *Emancipation and the Freed in American Sculpture.* Washington, D.C.: Published by the Author, 1916.

The Negro in Chicago, 1779–1929. Chicago: The Washington Intercollegiate Club of Chicago, 1929.

Nell, William, C. *Colored Patriots of the American Revolution.* Boston: Robert F. Wallcutt, 1855.

Parks, James Dallas. *Robert S. Duncanson: 19th Century Romantic Painter.* Washington, D.C.: Associated Publishers, 1980.

Patterson, Lindsay, comp. and ed. *The Negro in Music and Art.* International Library of Negro Life and Association for the Study of Negro Life and History. New York: Publishers Co., 1968.

Payne, Daniel A. *Recollections of Seventy Years.* Nashville: A.M.E. Sunday School Union, 1888.

Peterson, Edward. *History of Rhode Island.* New York: John S. Taylor, 1853.

Phillips, Ulrich B. *American Negro Slavery.* New York: Appleton, 1918.

Pinchbeck, R. B. *The Virginia Negro Artisan and Tradesman.* Richmond: William Byrd's Press, 1926.

Pleasants, J. Hall. *Joshua Johnston, the First American Negro Portrait Painter.* Baltimore: The Maryland Historical Society, 1942.

Porter, Dorothy B. *A Working Bibliography on the Negro in the United States.* Reproduced by University Microfilms, Ann Arbor, Michigan, for the National Endowment for the Humanities Summer Workshops in the Materials of Negro Culture, 1968.

Porter, James A. *Modern Negro Art.* New York: Dryden Press, 1943. Reprint: New York: Arno Press, 1969.

Prime, A. C. *The Arts and Crafts in Philadelphia, Maryland and South Carolina, 1721–1785: Gleanings from Newspapers.* Baltimore: The Walpole Society, 1929.

Quarles, Benjamin. *The Negro in the American Revolution.* New York: W. W. Norton & Co., 1961.

Quarles, Benjamin. *The Negro in the Civil War.* Boston: Little, Brown, 1953.

Register of Trades of Colored People in the City of Philadelphia and Districts. Philadelphia: Merrihew and Gunn, 1838.

Richardson, E. P. *A Short History of Painting in America.* New York: Harper and Row, 1963.

Richings, G. F. *Evidences of Progress Among Colored People.* Philadelphia: George S. Ferguson, 1899.

Rodman, Seldon. *Horace Pippin: A Negro Painter in America.* New York: Quadrangle Press, 1947.

Rose, Barbara. *American Art Since 1900: A Critical History.* New York: Praeger, 1967.

Simmons, W. J. *Men of Mark, Eminent, Progressive and Rising.* Cleveland: Revel, 1887.

Sonn, Albert. *Early American Wrought Iron.* New York: Scribner's, 1928.

Stauffer, David M. *American Engravers upon Copper and Steel.* New York: The Grolier Club, 1907.

Taft, Lorado. *The History of American Sculpture.* New York: Macmillan, 1924.

Thieme, Ulrich, and Becker, Felix. *Allgemeines Lexikon der Bildenden Künstler von der Antike bis Zurgegenwart.* Leipzig: Seeman, 1907–34.

Thomas, Isaiah. *The History of Printing in America with a Biography of Printers, and an Account of Newspapers, to Which is Prefixed a Concise View of the Discovery and Progress of the Art in Other Parts of the World.* Worcester, Massachusetts: From the Press of Isaiah Thomas, Isaac Sturtevant, Printer, 1810.

Tillinghast, J. A. *The Negro in Africa and America.* New York: Macmillan, 1902.

Tuckerman, Henry T. *Book of the Artists: American Artist Life, Comprising the Biographical and Critical Sketches of American Artists: Preceded by an Historical Account of the Rise and Progress of Art in America. With an Appendix Containing an Account of Notable Pictures and Private Collections.* New York: Putnam, 1882.

Van Vechten, Carl. *Nigger Heaven.* New York: Knopf, 1926.

Vlach, John. *The Afro-American Tradition in Decorative Arts.* Cleveland: Cleveland Museum of Art, 1978.

Walker, Margaret. *For My People.* New Haven: Yale University Press, 1942.

Washington, M. Bunch. *The Art of Romare Bearden.* New York: Abrams, 1972.

Werlein, Mrs. Phillip. *The Wrought Iron Railings of Le Vieux Carré.* New Orleans: Published by the Author, 1925.

Wheatley, Phillis. *Poems on Various Subjects, Religious and Moral.* London: Printed for A. Bell, Bookseller, Aldgate; and Sold by Messrs. Cox and Berry, King Street, Boston, 1773.

Wilmerding, John. *American Art.* New York: Penguin Books, 1976.

Wilson, Joseph. *Sketches of the Higher Classes of Colored Society in Philadelphia, by a Southerner.* Philadelphia: Merrihew and Thompson, 1841.

Woodruff, Hale A. *The American Negro Artist.* Ann Arbor: University of Michigan Press, 1956.

Woodson, Carter G. *A Century of Negro Migration.* Washington, D.C.: The Association for the Study of Negro Life and History, 1918.

————. *Free Negro Owners of Slaves in the United States in 1830 Together with Absentee Ownership of Slaves in the United States in 1830.* Washington, D.C.: Associated Publishers, 1924.

Wright, Richard. *Twelve Million Black Voices: A Folk History of the Negro in the United States.* New York: Viking Press, 1941.

CHAPTERS, PERIODICALS, MANUSCRIPTS, AND PAPERS

Adams, John Henry. "The New Negro Man." *Voice of the Negro* I (October 1904): 447-52.

"American Negro Art." *New Masses* 30 (December 1941): 27.

"American Negro Art at Downtown Gallery." *Design* (February 1942): 27-28.

"And the Migrants Kept Coming." *Fortune* (November 1941): 102-09.

"An Art Exhibition Against Lynching." *Crisis* (April 1935): 107.

"At God's Command." *Art Instruction* II (March 1928): 30.

Baker, James H., Jr. "Art Comes to the People of Harlem." *Crisis* (March 1939): 78-80.

"Baltimore Art by Negroes." *Art News* (11 February 1939): 17.

Barnes, Albert C. "Negro Artists and America." *Survey Graphic* LIII (March 1925): 669.

————. "Negro Art, Past and Present." *Opportunity* (May 1926): 148.

————. "Primitive Negro Sculpture and Its Influence on Modern Civilization." *Opportunity* (May 1928): 139.

Bearden, Romare. "The Negro Artists and Modern Art." *Opportunity* (December 1934): 371-72.

————. "The Negro Artist's Dilemma." *Critique: A Review of Contemporary Art* 1, No. 2 (November 1946): 16-22.

Bennett, Gwendolyn B. "The Future of The Negro in Art." *Howard University Record* (December 1924): 65-66.

Bennett, Mary. "The Harmon Awards." *Opportunity* (February 1929): 47-48.

Bentley, Florence L. "William A. Harper." *Voice of the Negro* III (February 1906): 85, 118-22.

Blodgett, Geoffrey. "John Mercer Langston and the Case of Edmonia Lewis, Oberlin, 1862." *Journal of Negro History* 53 (July 1968): 201-18.

Bontemps, Arna. "Special Collections of Negroana." *Library Quarterly* (July 1944): 187-206.

Bradford, S. Sidney. "The Negro Iron-Worker in Ante Bellum Virginia." *Journal of Southern History* 25 (May 1959): 194-206. Reprinted in Meier and Elliot M. Rudwick, eds., *The Making of Black America*, Vol. 1, New York, Atheneum, 1969.

Catlett, Elizabeth. "A Tribute to the Negro People." *American Contemporary Art* (Winter 1940): 17.

Childs, Charles. "Bearden: Identification and Identity." *Art News* 63 (October 1964): 24-25, 54.

Coleman, Floyd. "African Influences on Black American Art." *Black Art: An International Quarterly* (Fall 1976): 4-15.

Crum, William D. "The Negro at the Charleston Exposition." *Voice of the Negro* I (August 1904): 331.

Dabney, Wendell P. "Duncanson." In *Ebony and Topax, a Collectanea*, New York, National Urban League, 1927.

Driskell, David C. "Art by Blacks: Its Vital Role in U.S. Culture." *Smithsonian Magazine* (October 1976): 86-93.

————. "Bibliographies in American Art." *American Quarterly* XXX (1978): 374-94.

DuBois, Guy Pène. "Art by the Way." *International Studio* LXXVIII (March 1924): 322.

Du Bois, W.E.B. "Criteria of Negro Art." *Crisis* (May 1926): 290-97.

————. "The Immediate Program of the American Negro." *The Crisis* V, No. 6 (1915): 210-12.

"Federal Murals to Honor the Negro." *Art Digest* 1 (January 1943).

"Fifty-Seven Negro Artists Presented in Fifth Harmon Foundation Exhibit." *Art Digest* 1 (March 1933): 18.

Fine, Elsa Honig. "Mainstream, Blackstream and the Black Art Movement." *Art Journal* (Spring 1971): 374-75.

Freeman, P. "Origin, History and Hopes of the Negro Race." *Frederick Douglass' Paper* VII (Rochester, New York: 1854):6.

Goldberg, Marcia. "A Drawing by Edmonia Lewis." *The American Art Journal* 9 (November 1977): 104.

Greene, Carroll. "Perspective: The Black Artist." *Art Gallery* 13 (April 1970): 1-31.

Gunter, Carolyn Pell. "Tom Day, Craftsman." *Antiquarian* 10 (September 1928): 60-62.

"Harmon Exhibit of Negro Art, Newark Museum." *Newark Museum Bulletin* (October 1931): 178.

"Harmon Foundation Exhibition of Painting and Sculpture, Art Center." *Art News* (21 February 1931): 12.

Herring, James V. "The Negro Sculptor." *The Crisis* XLIX (August 1942): 261–62.

———. "The American Negro as Craftsman and Artist. *The Crisis* XLIX (April 1942): 116–18.

Holbrook, Francis C. "A Group of Negro Artists. *Opportunity* (July 1923): 211–13.

Hughes, Langston. "The Negro Artist and Racial Mountain." *The Nation* CXXII (1926): 662.

Hunter, Wilbur H., Jr. "Joshua Johnston: 18th-Century Negro Artist." *American Collector* 17 (February 1948): 6–8.

Johnson, James Weldon. "Race Prejudice and the Negro Artist." *Harper's* (November 1928): 769–76.

Jones, Steven L. "The Philadelphia Art Exhibits and Displays Showing the Work of Black American Artists from 1802 to 1969." Paper presented at the Pennsylvania Academy of the Fine Arts, Philadelphia, 1985.

Kendrick, Ruby M. "Art at Howard University." *The Crisis.* XXXIX (November 1932): 348.

Labouisse, S. S. "The Decorative Ironwork of New Orleans." *Journal of the American Institute of Architects* I (October 1913): 436–40.

"The Land of the Lotos-Eaters, Painted by R. S. Duncanson." *The Art Journal,* London, New Series, V (January 1866): 174–77.

Lawrence, Jacob. "…And the Migrants Kept Coming; A Negro Artist Paints the Story of the Great American Minority." *Fortune* XXIV (November 1941): 102–09.

Lester, William R. "Henry O. Tanner, Exile for Arts's Sake." *Alexander's Magazine,* Boston (December 15, 1908): 67–69.

Locke, Alain L. "American Negro as Artist." *American Magazine of Art* 23 (September 1931): 210–20.

———. "Chicago's New Southside Art Center." *Magazine of Art* (August 1941): 320.

———. "Negro Art in America." *Design* (December 1942): 12–13.

MacChesney, Clara T. "A Poet Painter of Palestine." *International Studio* IV (July 1913): XI-XIV.

McCausland, Elizabeth. "Jacob Lawrence." *Magazine of Art* 38 (November 1945): 250–54.

McElroy, Guy C. "Black Women Pioneers in the Visual Arts." Unpublished manuscript, 1984.

Moore, William H. "Richmond Barthé—Sculptor." *Opportunity,* (November 1928): 334.

Perry, Mary Lynn. "Joshua Johnson: His Historical Context and His Art." Unpublished master's thesis, George Washington University, 1983.

Pincus-Witten, Robert. "Black Artists of the '30's." *Artforum* (February 1969): 65–67.

Pleasants, J. Hall. "Joshua Johnston, the First Negro Portrait Painter." *Maryland Historical Magazine* 37 (June 1942): 121–49.

Porter, James A. "Four Problems in the History of Negro Art." *Journal of Negro History* XXVII (January 1942): 9–36.

———. "Henry O. Tanner." In *The Negro Caravan,* New York, The Dryden Press, 1942.

———. "Malvin Gray Johnson." *Opportunity* (April 1935): 117–18.

———. "Negro Art on Review." *The American Magazine of Art* XXVII (January 1934): 33–38.

———. "The Negro Artist and Racial Bias." *Art Front* (March 1936): 8.

———. "Robert S. Duncanson: Midwestern Romantic-Realist." *Art in America* 39, no. 3 (October 1951): 99–154.

———. "Versatile Interests of the Early Negro Artist." *Art in America and Elsewhere* XXIV (January 1936): 16–27.

Scarborough, William S. "Henry O. Tanner." *The Southern Workman* XXXI (December 1902): 661–70.

Schuyler, George S. "Negro Art Hokum." *The Nation* CXXII (June 1926): 662.

Scott, Emmett J. "The Louisiana Purchase Exposition." *Voice of the Negro* I (August 1904): 309.

Smith, Lucy E. "Some American Painters in Paris." *The American Magazine of Art* XVIII (March 1927): 134.

Stavisky, Leonard. "Negro Craftsmanship in Early America." *American Historical Review* 54 (1948–49): 315–25.

Tanner, Henry O. "The Story of the Artist's Life." *World's Work* XVIII (January, February 1909): 11661–6; 11769–75.

Wesley, Charles H. "Henry O. Tanner, the Artist—An Appreciation." *Howard University Record* XIV (April 1920): 299.

Winslow, Vernon. "Negro Art and the Depression." *Opportunity* (February 1941): 40–42, 62–63.

Woodruff, Hale. "My Meeting with Henry O. Tanner." *Crisis* 77 (January 1970): 7–12.

———. "Negro Artists Hold Fourth Annual in Atlanta." *Art Digest* (15 April 1945): 10.

EXHIBITIONS

"Aaron Douglas: Exhibition of Paintings." Fisk University International Student Center, Nashville. 1948.

"Aaron Douglas: Exhibition of Paintings." Stiles Street Y.W.C.A., Oklahoma City. 1950.

"Aaron Douglas Retrospective Exhibition." Carl Van Vechten, Gallery of Fine Arts, Fisk University, Nashville. March 21–April 15, 1971.

"American Negro Art: Nineteenth and Twentieth Centuries." Downtown Gallery, New York. December 9, 1941–January 3, 1942.

"American Paintings 1943–1948." Howard University, Washington, D.C. October 22–November 15, 1948.

"America's Black Heritage." Los Angeles County Museum of Natural History, Los Angeles. December 3, 1969–February 15, 1970.

"Art Exhibit: The Public Schools of the District of Columbia." Washington, D.C. May 3–11, 1931.

"The Art of Henry O. Tanner." Frederick Douglass Institute, with the National Collection of Fine Arts, Smithsonian Institution, Washington, D.C. July 23–September 7, 1969.

"The Art of the American Negro, 1851–1940." American Negro Exposition, Chicago. 1940.

"The Art of the American Negro; Exhibition of Paintings." Harlem Cultural Council, New York. June 27–July 25, 1966.

"The Art of the Negro." Harmon Foundation Traveling Exhibition, organized in cooperation with the College Art Association. New York. 1934.

"The Barnett-Aden Collection." Anacostia Neighborhood Museum, Smithsonian Institution. Washington, D.C. 1974.

"Black Artists of the 1930's." Studio Museum in Harlem, New York. 1968.

"Charles Alston: Exhibition of Paintings, Sculpture, Drawings and Watercolors." John Heller Gallery, New York. 1958.

"Charles White." The Gallery of Art, Howard University, Washington, D.C. September 22–October 25, 1967.

"Charles White: Drawings and Prints." ACA Gallery, New York. 1950.

"Charles White: Drawings and Prints." ACA Gallery, New York. 1958.

"Charles White: Recent Paintings." ACA Gallery, New York; Barnett-Aden Gallery, Washington, D.C. 1947.

"Charles White: Recent Paintings." ACA Gallery, New York. 1953.

"Edward Mitchell Bannister, 1828–1901: Providence Artist." Rhode Island School of Design, Providence. March 23–April 3, 1966.

"Eight New York Painters." University of Michigan, Ann Arbor. 1956.

"Eighteen Washington Artists." Barnett-Aden Gallery, Washington, D.C. 1953.

"Elizabeth Catlett." Studio Museum in Harlem, New York. September 26, 1971–January 9, 1972.

"Elizabeth Catlett, An Exhibition of Sculpture and Prints." Fisk University, Nashville. 1973.

"Elizabeth Catlett: The Negro Woman." Barnett-Aden Gallery, Washington, D.C. 1948.

"The Evolution of Afro-American Artists: 1800–1950." City College, New York. 1967.

"Exhibition." Organized by Hale Woodruff and the Harmon Foundation, Atlanta University, Atlanta. February 1934.

"An Exhibition of Paintings by Three Artists of Philadelphia: Laura Wheeler Waring, Allan Freelon and Samuel Brown." Howard University Gallery of Art, Washington, D.C. February 1–29, 1940.

"Exhibitions of Artists of Chicago and Vicinity." Art Institute of Chicago, Chicago. 1923.

"Exhibitions by Artists of Chicago and Vicinity." Art Institute of Chicago, Chicago. 1931.

"Exhibition of Block Prints by James Lesene Wells." Delphic Studios, New York. 1932.

"Exhibition of Fine Arts by American Negro Artists." Harmon Foundation, New York. January 7–19, 1930.

"Exhibition of Graphic Arts and Drawings by Negro Artists." Howard University Gallery of Art, Washington, D.C. 1935.

"Exhibition of Paintings and Drawings by James A. Porter and James Lesene Wells." Howard University Gallery of Art, Washington, D.C. April 16–30, 1930.

"Exhibition of Paintings and Sculpture by American Negro Artists at the National Gallery of Art." Smithsonian Institution, Washington, D.C. May 30–June 8, 1930.

"Exhibition of Productions by Negro Artists." Harmon Foundation, New York. February 20–March 4, 1933.

"An Exhibition of Sculpture and Prints by Elizabeth Catlett." Jacksonian Lounge, Jackson State College, Jackson, Mississippi. July 1–6, 1973.

"Exhibition of Works by Negro Artists at the National Gallery of Art." Smithsonian Institution, Washington, D.C. October 31–November 6, 1933.

"Exhibition of Works of Negro Artists." Harmon Foundation, New York. February 16–28, 1931.

"Exhibition of Works of Negro Artists." Harmon Foundation, New York. April 22–May 4, 1935.

"First Annual Exhibition Salon of Contemporary Negro Art." Augusta Savage Studios, New York. June 8–22, 1939.

"Five Famous Black Artists, Presented by the Museum of the National Center of Afro-American Artists: Romare Bearden, Jacob Lawrence, Horace Pippin, Charles White, Hale Woodruff." National Center of Afro-American Artists, Boston. February 9–March 10, 1970.

"Frank Alston: Exhibition of Paintings and Watercolors." The Barnett-Aden Gallery, Washington, D.C. 1948.

"Grafton Tyler Brown: Black Artists in the West." Oakland Museum, Oakland, California. February 11–April 22, 1972.

"Harlem Art Teacher's Exhibit." Harlem Community Art Center, New York. October 17, 1938.

"Harlem Art Workshop Exhibition." New York Public Library, 135th Street Branch, New York. 1933.

"Henry O. Tanner: An Afro-American Romantic Realist." Spelman College, Atlanta. March 30–April 30, 1969.

"Highlights from the Atlanta University Collection of Afro-American Art." The High Museum of Art, Atlanta. October 1973.

"H. Pippin." The Phillips Collection, Washington, D.C. February 25–March 27, 1977.

"Horace Pippin." Carlen Galleries, Philadelphia. 1940.

"Horace Pippin: Recent Paintings." Carlen Galleries, Philadelphia. 1941.

"Jacob Lawrence." American Federation of Artists, New York. 1960.

"Jacob Lawrence." Whitney Museum of American Art, New York. May 16–July 7, 1974.

"James Porter: Recent Paintings and Drawings." Barnett-Aden Gallery, Washington, D.C. 1948.

"Laura Wheeler Waring—In Memoriam: An Exhibition of Paintings." Howard University Gallery of Art, Washington, D.C. 1949.

"Lois Mailou Jones: Retrospective Exhibition." Howard University Gallery of Art, Washington, D.C. March 31–April 21, 1972.

"The Negro Artist Comes of Age: A National Survey of Contemporary American Artists." Albany Institute of History and Art, Albany, New York. January 3–February 11, 1945.

"Negro Artists of the Nineteenth Century." Harlem Cultural Center, New York. 1966.

"The Negro in American Art." University of California, Los Angeles. September 11–October 16, 1966.

"New Names in American Art." The G Place Gallery, Washington, D.C. June 13–July 4, 1944.

"Paintings and Sculptures by Four Tennessee Primitives." Nicholas Roerich Museum, New York. January 12–February 19, 1964.

"Paintings by Ellis Wilson, Ceramics and Sculpture by William E. Artis." Carl Van Vechten Gallery of Fine Arts, Fisk University, Nashville. April 18–June 2, 1971.

"Paintings and Prints by James Lesene Wells." Barnett Aden Gallery, Washington, D.C. 1950.

"Paintings, Sculptures by American Negro Artists." Institute of Contemporary Art, Boston. January 5–20, 1943.

"Palmer Hayden." Carl Van Vechten Gallery of Fine Arts, Fisk University, Nashville. 1970.

"Palmer Hayden: The John Henry Series and Paintings Reflecting the Theme of Afro-American Folklore." Fisk University, Nashville. February 22–March 30, 1970.

"The Portrayal of the Negro in American Painting." The Bowdoin College Museum of Art, Brunswick, Maine. 1964.

"Robert S. Duncanson: A Centennial Exhibition." Cincinnati Art Museum, Cincinnati. March 16–April 30, 1972.

"Sargent Johnson." The Oakland Museum, Oakland, California. February 23–March 21, 1971.

"Selections of Nineteenth Century Afro-American Art." The Metropolitan Museum of Art, New York. June 19–August 1, 1976.

"Selma Burke: Sculptures and Drawings. Avant-Garde Gallery, New York. 1958.

"Ten Afro-American Artists of the Nineteenth Century." Howard University Gallery of Art, Washington, D.C. February 3–March 30, 1967.

"Three Negro Artists: Horace Pippin, Richmond Barthé and Jacob Lawrence." Phillips Memorial Gallery, Washington, D.C. 1946.

"Three Self-Taught Pennsylvania Artists: Hicks, Kane, Pippin." Museum of Art, Carnegie Institute, Pittsburgh. October 21–December 4, 1966.

"Two Centuries of Black American Art." Los Angeles County Museum of Art, Los Angeles. September 30–November 21, 1976.

"William H. Johnson: 1901–1970." National Collection of Fine Arts, Smithsonian Institution, Washington, D.C. November 5, 1971–January 9, 1972.

THE ART MUSEUM ASSOCIATION OF AMERICA
BOARD OF TRUSTEES

President
Christian Frederiksen
Alexander Grant and Company
San Francisco, CA

Chairman
Robert K. Hoffman
President, The Coca-Cola Bottling Group (Southwest) Inc.,
Dallas, TX

Vice President
Roger Mandle
Director, The Toledo Museum of Art, Toledo, OH

Vice President
Tom Freudenheim
Director, Worcester Art Museum, Worcester, MA

Vice President
Lyndel King
Director, University Art Museum, University of Minnesota,
Minneapolis, MN

Treasurer
John M. Cranor
President, Wilson Sporting Goods, River Grove, IL

Secretary
Thomas K. Seligman
Deputy Director, Education and Exhibitions, The Fine Arts
Museums of San Francisco, CA

Ben F. Cubler
Manager, Corporate Property, Atlantic Richfield Company,
Los Angeles, CA

Hugh M. Davies
Director, La Jolla Museum of Contemporary Art, La Jolla, CA

Thomas H. Garver
Director, Madison Art Center
Madison, WI

William J. Hokin
Chicago, IL

Joseph F. McCann
Vice President, Public Affairs, PepsiCo., Inc., Purchase, NY

Cheryl McClenney
Assistant Director for Programs, Philadelphia Museum of
Art, Philadelphia, PA

Marena Grant Morrisey
Director, Loch Haven Art Center, Orlando, FL

George W. Neubert
Director, Sheldon Memorial Art Gallery, University of
Nebraska, Lincoln, NB

David W. Steadman
Director, The Chrysler Museum, Norfolk, VA

Marcia Tucker
Director, The New Museum of Contemporary Art, New York,
NY

Stephen E. Weil
Deputy Director, Hirshhorn Museum and Sculpture Garden,
Smithsonian Institution, Washington, D.C.

STAFF

Lynn J. Upchurch
Executive Director

Maureen Keefe
Assistant to the Director and Insurance Administrator

Exhibitions
Harold B. Nelson
Exhibition Program Director

Joanna C. Sikes
Exhibition Coordinator

Miriam Roberts
Exhibition Coordinator

Beth Goldberg
Registrar

Bradin L. Anders
Exhibition Assistant

Museum Management Institute
Davida A. Egherman
Professional Training Director

Jennie Watson
Education Assistant

Computer Services
Gigi Dobbs Taylor
Computer Services Director

Eric Brizee
Computer Services Assistant

Membership and Development
Jerry M. Daviee
Planning & Development Director

Pauline Facciano
Membership and Development Assistant

Accounting
Erlinda Cruz-Cunanan
Accountant

Lilani Marquez
Administrative Assistant

PHOTO CREDITS

Photograph © Allen Memorial Art Museum: Fig. 32. Photograph © The Corcoran Gallery of Art: Fig. 5. Photographs by Chris Eden: Figs. 8, 10, 13, 15 18, 19, 20, 24, 25 26, 27, 28, 29, 30, 33, 34, 35, 36, 37, 40, 41, 42, 43, 45, 46, 48, 50, 51, 54, 55, 57, 58, & 59. Photograph by Janice Felgar: Fig. 53. Photographs by Clem Fiori: Figs. 3 & 4. Photographs by Mike Fischer: Figs. 39, 44, & 52. Photograph by Margaret Harmon: Fig. 7. Photograph by Edward Owen: Fig. 14. Photographs © Manu Sassoonian: Figs. 47 & 49. Photographs by David Stansbury: Figs. 2 & 17. All other photographs courtesy of the lender.